IMAGES
of America

CATHOLIC
WEST VIRGINIA

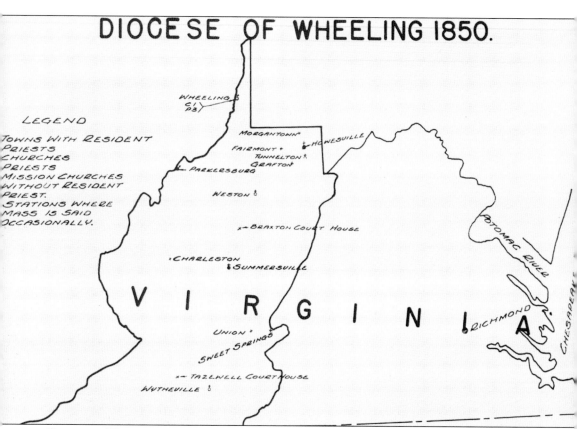

DIOCESE OF WHEELING 1850.

WHEELING B
C1
P3

LEGEND

TOWNS WITH RESIDENT
PRIESTS
CHURCHES
PRIESTS
MISSION CHURCHES
WITHOUT RESIDENT
PRIEST.
STATIONS WHERE
MASS IS SAID
OCCASIONALLY.

MORGANTOWN
FAIRMONT + HOWESVILLE
TUNNELTON
GRAFTON
PARKERSBURG
WESTON

x— BRAXTON COURT HOUSE

CHARLESTON
SUMMERSVILLE

V I R G I N I A

UNION +
SWEET SPRINGS

x— TAZEWELL COURT HOUSE
WYTHEVILLE

POTOMAC RIVER
RICHMOND
CHESAPEAKE

DIOCESE OF WHEELING MAP, 1850. On July 19, 1850, which was prior to the formation of the state of West Virginia, Pope Pius IX established the new Diocese of Wheeling. By the time Bishop Richard V. Whelan died in 1874, the diocese had quadrupled in size. This map shows the boundaries and new cities in the diocese. (Courtesy of the Diocese of Wheeling-Charleston Archives.)

ON THE COVER: MAY PROCESSION, 1940s. In photograph, parishioners of St. John Parish in Benwood march down Main Street in their annual May procession. (Courtesy of the Diocese of Wheeling-Charleston Archives.)

IMAGES
of America

CATHOLIC
WEST VIRGINIA

Ryan Rutkowski

ARCADIA
PUBLISHING

Published by Arcadia Publishing
Charleston, South Carolina

Printed in the United States of America

Library of Congress Control Number: 2010924489

For all general information, please contact Arcadia Publishing:
Telephone 843-853-2070
Fax 843-853-0044
E-mail sales@arcadiapublishing.com
For customer service and orders:
Toll-Free 1-888-313-2665

Visit us on the Internet at www.arcadiapublishing.com

To the Catholics of West Virginia

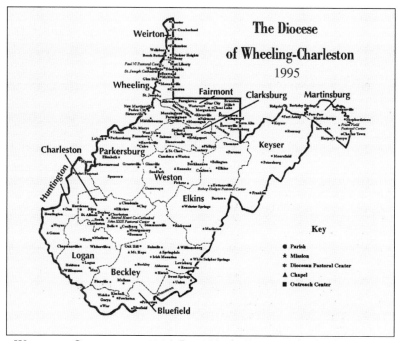

DIOCESE OF WHEELING-CHARLESTON, 1995. By 1980, the Diocese of Wheeling had gone through a number of changes. In 1974, the boundaries of the diocese were redrawn to correspond with those of the state of West Virginia. In addition, Bishop Joseph H. Hodges renamed the Diocese of Wheeling to the Diocese of Wheeling-Charleston to reflect its new status and as well as to express a more inclusive name for Catholics located in the southern region of the diocese. This map shows these changes and also illustrates how much the diocese had grown since 1850. (Courtesy Diocese of Wheeling-Charleston Archives.)

CONTENTS

ACKNOWLEDGMENTS

This book would not have been possible without the support of the Roman Catholic Diocese of Wheeling-Charleston, especially Bishop Michael J. Bransfield and Chad Carter, the Chancellor of the Diocese. I would also like to thank Marian Dantzler, who helped edit the book. The book would not have come together without the collection of photographs that were collected by my predecessors in the archives department. I would like to thank Emily White, Tracy Rasmer, Margret Brennan, and Tricia Pyne, whose book *Faith in the Mountain: A History of the Diocese of Wheeling-Charleston 1850–2000* played an invaluable role in inspiring this text. I want to acknowledge the photographers, studios, archives, and newspaper companies whose photographs are a true window into the history of the diocese, which include the following: Charles F. Gruber Studios, the *West Virginia Catholic Register*, the *Catholic Spirit*, Dorsey Photo, Levitt Photo, the Mount de Chantal Visitation Academy Archives, and Carmelite Sisters of the Carmelite Monastery Archives. I am grateful to all of you.

INTRODUCTION

The year 2010 marks the 160th anniversary of the Diocese of Wheeling-Charleston. In over a century and a half, the diocese has overcome its tumultuous beginnings and matured into a distinguished and active voice for Catholic West Virginians. One of the most unique facets of the diocese is that it covers the entire state of West Virginia. It mirrors the diversity of the landscape, culture, ethnicity, and dialect that characterizes the state's identity. From Wheeling to Charleston and Martinsburg to Parkersburg, the story of our diocese comes from the individuals who established and nurtured the Catholic faith in their local communities. Without generations of the dedicated faithful, the diocese would not have thrived.

From the foundation of the diocese, its story was riddled with struggles and tribulations. As Bishop of Richmond, Richard V. Whelan saw the need to divide the Diocese of Richmond along the natural boundary of the Alleghany Mountains. Eventually, Whelan became the first bishop of the Diocese of Wheeling. However, his practical vision of developing the young diocese was complicated by a shortage of both money and priests. With the dedication of the clergy and the laity that followed him, the diocese was able to grow and establish a successful and vibrant Catholic community. Through images, this book will tell the story of the generations that continued striving to give a voice to this unique Catholic community.

The images and stories illustrated in this book will cover almost every era and community in the diocese's history, from the Italian coal miners in the Clarksburg area to opening of St. Michael's Grammar School in 1930. These hardworking West Virginians contributed to the legacies of their state and nation while they remained committed to their Catholic identity and heritage. These images will depict Catholics involve in their faith, family, community, and work. This book will not only commemorate the 160 years of our diocese but will also honor the men and women who made this diocese possible.

While the diocese is diverse in many ways, this book will also illustrate what the Catholic community in West Virginia has in common—its values. These values, such as humility and charity forged from humble beginnings, have helped maintain the identity of Catholic West Virginia. Professional researchers and local readers alike will find this book's rare perspective of history through the lived experiences of the subjects to be refreshing.

Researchers often come to the West Virginia Catholic Heritage Center's archives seeking particular materials; they usually make the surprising discovery of the large volume of Catholic presence in West Virginia's history. For example, the Italian coal miners in Clarksburg are a very interesting study in ethnic, industrial, and regional history. However, many may be unaware that what built the communities of these Italian immigrants and coal miners was their Catholic faith. This book will shed light on that connection and many others, which are still important to the Catholics of West Virginia.

One

THE BISHOPS

Since its inception, the Diocese of Wheeling-Charleston has been under the direction of eight bishops who have overseen the creation and development of the newly created Diocese of Wheeling. From the first bishop, Richard V. Whelan, to Bishop Michael J. Bransfield, the Diocese of Wheeling-Charleston has been lead by men of strong spirit and great integrity. While each of the bishops has come from different backgrounds, they share a common purpose in promoting the continual growth and prosperity of the Catholic community. Whether it was the founding of the diocese or the great mining disaster at Upper Big Branch Mine in Montcoal, these bishops have guided West Virginians through both turmoil and triumph. This chapter highlights who these men are and each of their places in the history of the diocese.

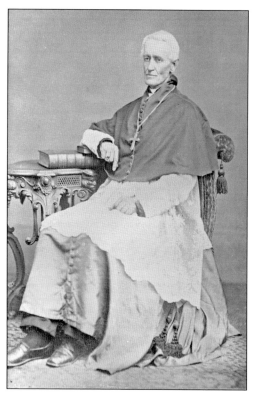

BISHOP RICHARD V. WHELAN, 1850–1874. Bishop Whelan was the founding father and first Bishop of the Diocese of Wheeling-Charleston. As the Bishop of Richmond, Bishop Whelan became convinced that the Diocese of Richmond needed to be divided. Due to the vastness of the diocese, Bishop Whelan believed that the natural barrier formed by the Allegheny Mountains should divide it. So in a papal decree dated July 19, 1850, Pope Pius IX created the Diocese of Wheeling. During his 24 years of service as the Bishop of Wheeling, Bishop Whelan oversaw the building of 42 churches, 9 schools, 1 orphanage, and a hospital. By the time of his death in 1874, the Catholic population had grown to 18,000. (Both, courtesy of Mount de Chantal Visitation Academy Archives.)

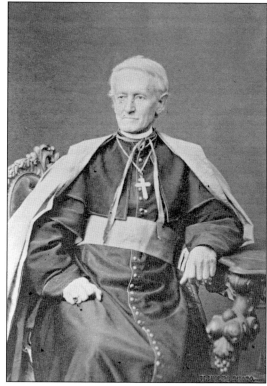

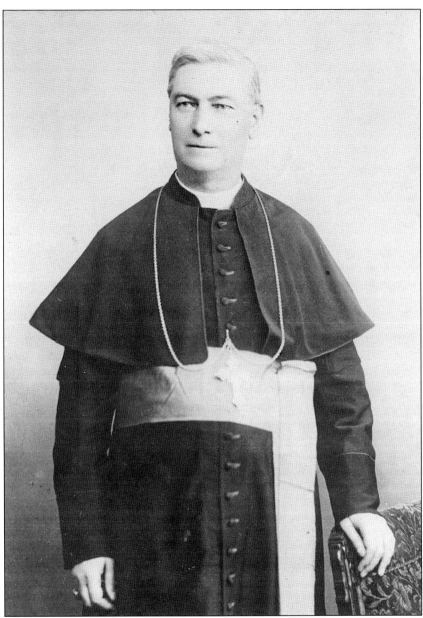

Bishop John J. Kain, 1874–1893. As the second Bishop of Wheeling, Bishop Kain worked very hard to eliminate the enormous debt that Bishop Whelan left him. One of the reasons he was able to eliminate the debt was that the Catholic population had only grown 11 percent during his 18-year stay in Wheeling. It had only risen from 18,000 to about 20,000 people, and this lessened the demand for new churches, schools, and other buildings. Another goal Kain tried to achieve was redrawing the boundaries of the Diocese of Wheeling. When he first took office, he tried to tackle the issue, but it was rejected. Finally, by 1888, he got approval for his request, but the document was lost in the Vatican, and the issue was not resolved until 1974, when the Vatican found the document. In 1893, he was appointed to the position of Archbishop of St. Louis. He served for 10 years as Archbishop of St. Louis until his death in 1903. (Courtesy of the Diocese of Wheeling-Charleston Archives.)

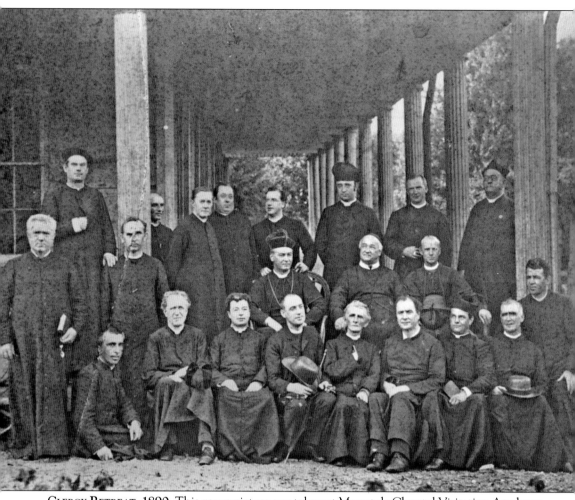

CLERGY RETREAT, 1890. This group picture was taken at Mount de Chantal Visitation Academy in the episcopate of Bishop John J. Kain. Pictured are, from left to right, the following: (first row) Fathers Michael Fitzpatrick, ? Boutlou, Robert Keleher, ? Collins, John McElligott, Henry Parke, Terrence Duffy, ? Schilp, Daniel O'Connor, and ? Deehan; (second row) Fathers Tracy and William Walsh, Bishop John J. Kain, Father Wissel of the Congregation of the Most Holy Redeemer (C.Ss.R.), and Msgr. John Sullivan, the vicar general; (third row) Fathers E. Olivier, E. M. Hickey, ? Gratz, George H. Toner, Francis E. McGrath, John A. Reynolds, and William Lambert. (Courtesy of the Mount de Chantal Visitation Academy Archives.)

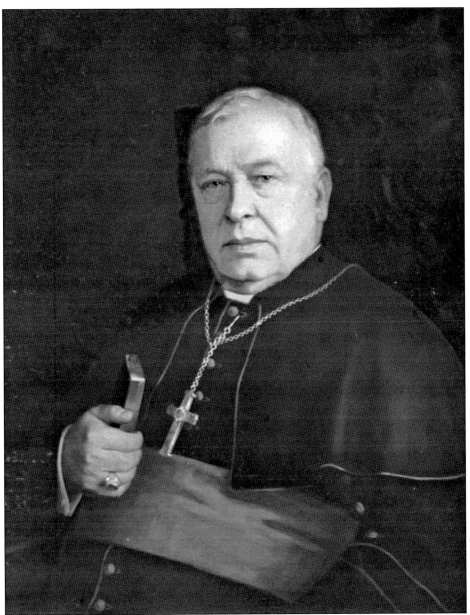

BISHOP PATRICK J. DONAHUE, 1894–1922. Bishop Donahue was born in Malvern, England, on April 15, 1845. In 1855, he was ordained a priest by then-Archbishop James Gibbons. Donahue then spent a year as assistant pastor at St. John's Church, Baltimore, after which he was appointed chancellor of the archdiocese and served as the newly appointed Cardinal Gibbons's secretary. In 1893, Bishop John J. Kain was moved from Wheeling to St. Louis, and on January 22, 1894, Donahue was ordained his successor. During his term as bishop of the Diocese of Wheeling, Bishop Donahue fought for the workingman and the immigrant and endeavored to spread the faith into the most remote parts of West Virginia. He struggled against national conflicts, including friction from immigration, the hardships of industrialization, and socialism. By his death in 1922, Bishop Donahue had earned the respect not only of the community in which he served but also of politicians and presidents. (Courtesy of the Diocese of Wheeling-Charleston Archives.)

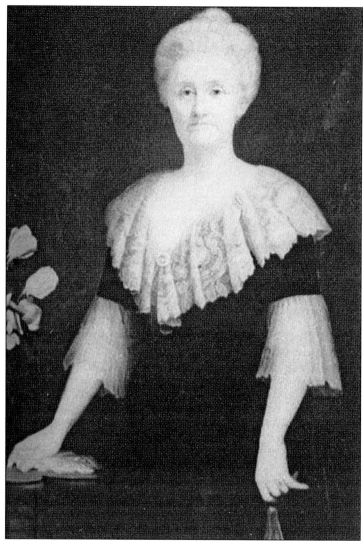

SARA C. TRACY, 1827–1904. Born on December 6, 1827, in New York, Sara C. Tracy was the heiress to her brother Edward Tracy's fortune and spent the rest of her life traveling the world and supporting numerous charitable activates. While on a ship en route to Rome in February 1899, Sara Tracy met Bishop Patrick J. Donahue. Their acquaintance began when the bishop challenged a fellow passenger to a game of chess. As the game lasted into the night, word of the heated competition spread throughout the ship. Impressed by the story, Tracy approached Bishop Donahue the following day to seek his advice on a personal matter, and a close friendship soon developed. As they were disembarking the ship, Tracy slipped a check for $5,000 into the bishop's hands as "a little offering" for the diocese. This would be the first of many such gifts. Until her death in 1904, Tracy would generously support the bishop's work in the diocese, and when she died, Tracy left here entire estate to Bishop Donahue. Through her generosity, Bishop Donahue was to build Good Shepherd Convent and Home for Young Women in Wheeling, St. Edward's Preparatory College in Huntington, and a number of charitable institutions. In 1955, Wheeling College (now Wheeling Jesuit University) was also found with money from her estate. Even today, the Catholics of the diocese continue to benefit from Sara Tracy's bequest. (Courtesy of the Diocese of Wheeling-Charleston Archives.)

BISHOP JOHN J. SWINT, 1922–1961. Born on December 15, 1879, this bishop was a native of West Virginia, from the town of Pickens. Bishop Swint was ordained as a priest by Bishop Patrick J. Donahue on June 23, 1904. As a priest, he served St. John in Wellsburg, St. Patrick in Hinton, and St. Patrick in Weston. For several years, Bishop Swint also held missionary duties, traveling the West Virginia countryside, either on horseback or on foot, holding services in meeting halls, courthouses, and even private homes. With death of Bishop Donahue on October 4, 1922, Bishop Swint was named the fourth bishop of the Diocese of Wheeling, and on the 50th anniversary of Swint's ordination, Pope Pius XII conferred on him the title of archbishop. Nicknamed "God's Bricklayer," Archbishop Swint oversaw the tremendous growth in the diocese. In his 40 years as bishop, the Catholic population doubled, and he oversaw the construction of 100 churches, a new cathedral, a college (Wheeling Jesuit University), 52 elementary and high schools, and 5 hospitals. Archbishop Swint devoted his life to being a vigorous and outspoken defender of the Catholic Church in West Virginia. (Both, courtesy of the Diocese of Wheeling-Charleston Archives.)

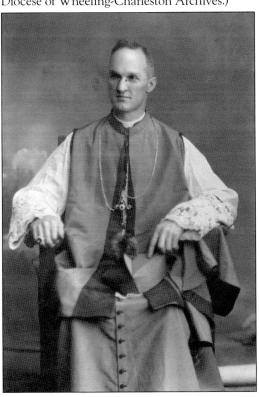

BISHOP THOMAS J. MCDONNELL, 1951–1961. Bishop McDonnell was ordained to the priesthood on September 20, 1919, and for the next 30 years, the Catholic community of the Archdiocese of New York was his main priority. In 1947, he was appointed auxiliary to the Archbishop Francis Spellman of New York. In 1951, Bishop McDonnell was appointed coadjutor bishop with the right of succession to Bishop Swint. Over his 10 years of service, Bishop McDonnell assumed many of the Bishop Swint's duties and traveled extensively throughout the diocese. He also was instrumental in the development of lay leadership through the promotion of such organizations as the Serra Club, the Holy Names Societies, and the International Federation of Catholic Alumni. Bishop McDonnell was as active in civil affairs, serving on several state commissions, including the Commission to Study the Constitution of the State. He is acknowledged as having played an instrumental role in having the word God placed in the preamble of the State Constitution. Born on August 18, 1894, Bishop McDonnell died unexpectedly on February 25, 1961. (Courtesy of the Diocese of Wheeling-Charleston Archives.)

Bishop Joseph H. Hodges, 1962–1985.
Born on October 8, 1911, in Harper's Ferry, West Virginia, Bishop Hodges was ordained to the priesthood in 1935 for the Diocese of Richmond. In 1952, Bishop Hodges was made auxiliary bishop of the Diocese of Richmond, a post he held until he was appointed coadjutor bishop with right of succession to Archbishop Swint in 1961. After the death of Archbishop Swint in November 23, 1962, Bishop Hodges was appointed the fifth bishop of the Diocese of Wheeling. During his 23 years of service, Bishop Hodges was involved in the Second Vatican Council and helped usher in a new era for the Catholic Church in West Virginia. He was also involved in the renaming of the Diocese of Wheeling to the Diocese of Wheeling-Charleston and redrawing the diocese's boundaries to correspond with those of the state. Bishop Hodges's legacy was that of a reformer who challenged the Catholic community of West Virginia to become engaged in the world around them, to reach out to those in need, and to fight injustice. (Both, courtesy of the Diocese of Wheeling-Charleston Archives.)

BISHOP JAMES E. MICHAELS, 1973–1987. Born on May 30, 1926, in Chicago, Bishop Michaels was ordained to the priesthood on December 21, 1951. In 1966, he was appointed Auxiliary Bishop of Kwang Ju, South Korea. A year after his return to the United States in 1972, Bishop Michaels accepted Bishop Hodges's invitation to serve as an auxiliary bishop. During his 14 years with the diocese, he acted as vicar general, diocesan consultor, and pastor of St. Francis Xavier in Parkersburg (1976–1982) and St. Francis de Sales Parish in Beckley (1982–1987). In 1987, Bishop Michaels resigned his episcopacy. (Courtesy of the Diocese of Wheeling-Charleston Archives.)

BISHOP FRANCIS B. SHULTE, 1985–1989. Born on December 25, 1927, in Philadelphia, Bishop Shulte was ordained to the priesthood on May 10, 1952. In 1981, Bishop Shulte was named auxiliary bishop of the Archdiocese of Philadelphia, a position he served until he was named the successor to Bishop Hodges in June 1985. During his short term with the diocese, Bishop Shulte dedicated his efforts towards the creation of a number of programs, such as the Department of Catholic Education and Formation and the Summer Ministry to further the education and spiritual formation of the diocese's Catholics. On February 14, 1989, Bishop Shulte was appointed archbishop of the Archdiocese of New Orleans, a position in which he served until 2001. (Courtesy of the Diocese of Wheeling-Charleston Archives.)

BISHOP BERNARD W. SCHMITT, 1989–2004. Born in the Diocesan seat of Wheeling, West Virginia, on August 17, 1928, he was ordained to the priesthood on May 28, 1955. For the next 34 years, Bishop Schmitt served as associate pastor of the Cathedral of St. Joseph, master of ceremonies to Archbishop Swint, director of vocations, rector of St. Joseph Preparatory Seminary, and pastor of St. Francis of Assisi Parish in St. Albans and St. Michael Parish in Wheeling. On May 31, 1988, Bishop Schmitt was appointed auxiliary bishop to Bishop Schulte, and he was selected to succeed Bishop Shulte as the seventh bishop on March 30, 1989. During his 15 years of service, Bishop Schmitt focused his attention on the spiritual development and formation of the people of the diocese and the renewal of every parish into a vibrant faith community. In 2004, Bishop Schmitt resigned his episcopacy. (Courtesy of the Diocese of Wheeling-Charleston Archives.)

BISHOP MICHAEL J. BRANSFIELD, 2004–PRESENT. Bishop Bransfield was born on September 8, 1943, in Philadelphia and was ordained to the priesthood on May 15, 1971. In 1980, Bishop Bransfield was appointed assistant director and director of liturgy at the National Shrine of the Immaculate Conception in Washington, D.C. Over the next 15 years, Bishop Bransfield was named the director of finance (1982), appointed as the 10th director of the National Shrine (1986), and was named a Prelate of Honor by His Holiness Pope John Paul II (1987); when the National Shrine was designated a basilica in 1990, Bishop Bransfield was named the first rector. On February 22, 2005, he was ordained and installed as the eighth bishop of Wheeling-Charleston at the Cathedral of St. Joseph in Wheeling. (Courtesy of the Diocese of Wheeling-Charleston Archives.)

Two

SACRED PLACES

While the history and story of the diocese are seen through the eyes of the Catholic community and the leadership of the bishops, the churches, schools, cemeteries, and other Catholic institutions have been the forum where the events and periods of Catholics' lives have unfolded. From weddings and funerals to May Queen ceremonies and graduations, these sacred places and spaces tell the story of Catholic West Virginians. These architectural wonders, built by the hands of immigrants, and the beautiful landscapes that dot the rolling hills of West Virginia have been instrumental in uniting this strong religious community in prayer and worship. This chapter highlights some of these places that have a special connection to the Catholic community and have facilitated the story of Catholic West Virginia.

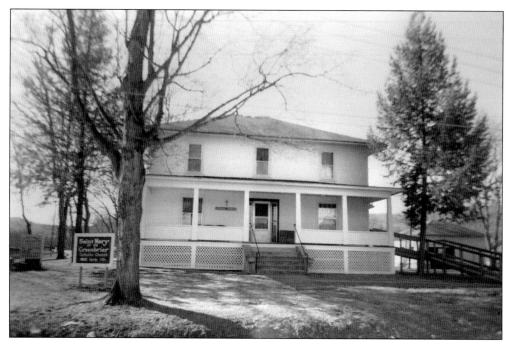

ST. MARY OF THE GREENBRIER MISSION, ALDERSON. Located in the far southern part of West Virginia, the Alderson Catholic Center, which is a mission of St. Patrick in Hinton, was dedicated by Bishop Joseph J. Hodges on February 18, 1979. The Catholic Center, which serves the Catholic populations of Summers, Monroe, and Greenbrier Counties, is located in a two-story wooden house. (Courtesy of the Diocese of Wheeling-Charleston Archives.)

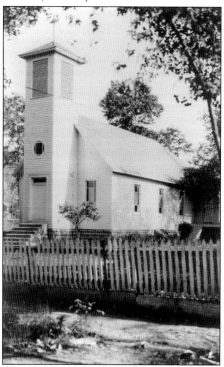

ST. PATRICK PARISH, BANCROFT. Located in Putnam County, south of the Kanawha River, Catholic presence in the region predates the founding of the diocese. Fertile land and abundant coal drew many of the county's early settlers, including a number of Catholics. Rev. Joseph Stenger, the "The Apostle of the Kanawha Valley," was the first priest to minister to the families of Putnam County. In 1893, St. Patrick Mission was built, and it was dedicated in 1906. St. Patrick's is currently a mission of Holy Trinity Parish in Nitro. (Courtesy of the Diocese of Wheeling-Charleston Archives.)

ST. JOHN PARISH, BENWOOD. The first Catholic church in Benwood was dedicated to St. John in 1871, but the community did not have a resident pastor until Rev. P. F. McKernan was assigned in 1875. Close to the Ohio River, the church was victim to numerous floods. In 1891, the cornerstone was laid for the second church. The parish's initial families were comprised of at least 15 different ethnic groups; they were all drawn to the area by opportunities in the steel and coal industries. (Courtesy of the Diocese of Wheeling-Charleston Archives.)

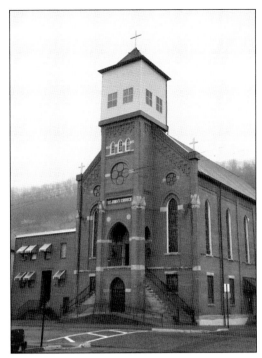

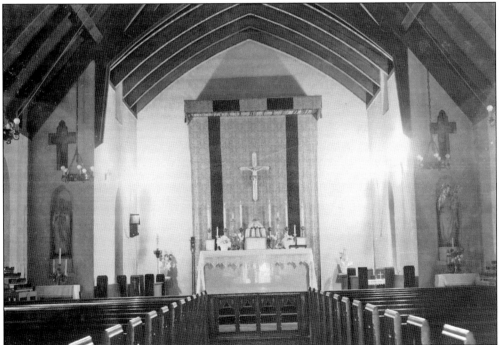

ST. VINCENT DE PAUL PARISH, BERKELEY SPRINGS. This town can claim one of the oldest Catholic communities in the diocese. The community was a mission of St. Joseph Parish in Martinsburg from 1821 until it was designated a parish in 1931. Since the mid-1830s, three churches have been constructed. This church was dedicated in 1932. The interior image of the third church is from the mid- to late 1930s. (Courtesy of the Diocese of Wheeling-Charleston Archives.)

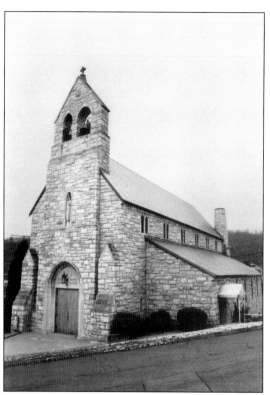

SACRED HEART PARISH, BLUEFIELD. Many Catholics came to work in the coalfields in southern West Virginia at the end of the 19th century. Traveling priests visited the families on occasion from St. Mary's Parish in Wytheville, until the first resident pastor, Rev. Emil Olivier, was appointed in 1894. Mass was held at the Bluefield Inn and an old laundry until the first church was built in 1925. (Courtesy of the Diocese of Wheeling-Charleston Archives.)

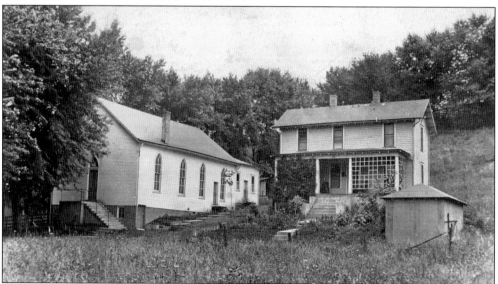

HOLY ROSARY PARISH, BUCKHANNON. The Catholic presence in Upshur County dates back to the middle of the 19th century. However, Buckhannon's first church was dedicated in 1895 to St. Joseph. Initial members were descendants of Irish laborers who had settled in the region. The Marist Fathers came into the parish in 1903 and continue to serve there today. In 1957, the church was re-designated as Holy Rosary, and a new church was constructed. This image is of the original St. Joseph Parish and Rectory that was dedicated in 1895. (Courtesy of the Diocese of Wheeling-Charleston Archives.)

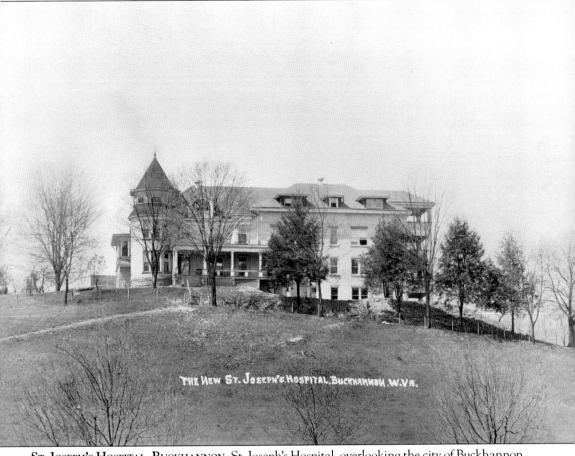

The New St. Joseph's Hospital. Buckhannon. W.Va.

St. Joseph's Hospital, Buckhannon. St. Joseph's Hospital, overlooking the city of Buckhannon, has been an integral part of the history of the Buckhannon community. The history of the hospital has been influenced by the work of the Pallottine Sisters, who had established a successful hospital in Richwood, Virginia. Seeing their work first hand, Fr. Nicholas Hengers, who had established a mission parish in Buckhannon, saw a need for a hospital in Buckhannon. With the help of the citizens, Father Hengers was able to raise the $27,000 needed to buy the Barlow mansion. The renovated mansion was opened as St. Joseph's Hospital on March 28, 1921. St. Joseph's Hospital provided comprehensive health care to the community and served as a training site for nursing students of West Virginia Wesleyan College. The hospital continued to provide for the community of Buckhannon until a new hospital was constructed in 1966. (Courtesy of the Diocese of Wheeling-Charleston Archives.)

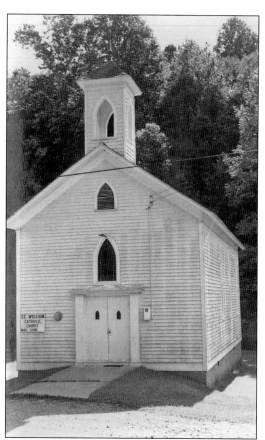

ST. WILLIAM'S MISSION, CAIRO. St. William Church, a mission church of Sacred Heart Parish in Salem, was built in 1932 with $1,686, donated labor, and parts from three other churches. The real foundation of the parish was started many years prior through the faith and devotion of the 19th-century laborers and farmers who brought the church with them as they settled in the hills and hollows of Ritchie County. In 1990, the mission church was suppressed. (Courtesy of the Diocese of Wheeling-Charleston Archives.)

ST. BONIFACE PARISH, CAMDEN. This Lewis County community was initially known as Leading Creek. In the 1840s, German and Irish immigrants settled in the region to farm. Before this church was built in 1851, mass was celebrated in the Bernard Kraus family home. St. Boniface was the mission church for St. Clare Parish in St. Clara from its construction until it became an independent parish in 1875 due to the shift in population over the years. (Courtesy of the Diocese of Wheeling-Charleston Archives.)

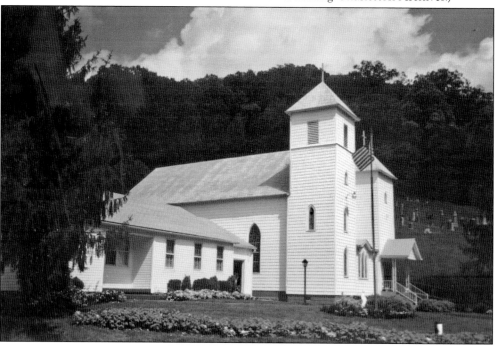

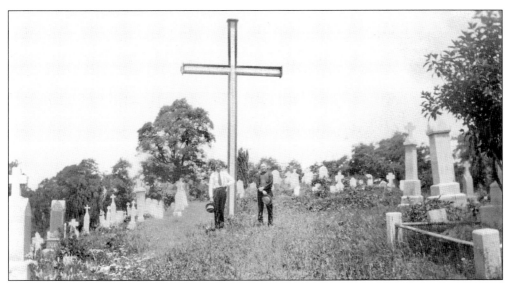

St. Martin Parish and Cemetery, Cameron. This photograph of St. Martin's Cemetery, located on the grounds of the parish, was taken in 1931. Families from Belton, Moundsville, McMechen, and Benwood used the cemetery. The origin of St. Martin Parish dates back to the 1850s, with the arrival of the Baltimore and Ohio Railroad in Marshall County. Initial members of the church were Irish immigrants who had worked on the railroad. In 1862, a priest started to visit the community regularly, and it was soon established as a mission church of St. Francis Xavier in Moundsville. Mass was held in private homes until a church was built in 1871. Until its first residential priest was appointed in 1979, St. Martin remained a mission church. (Both, courtesy of the Diocese of Wheeling-Charleston Archives.)

ST. JAMES PARISH, CHARLES TOWN. In 1889, St. James Parish was established as a mission of St. Peter Parish in Harper's Ferry. A small, Gothic-style church was built for the community's initial 50 members. Due to the parish's growth in the early 20th century, the pastor's residence was transferred from Harper's Ferry to Charles Town. In 1977, the parish went through a renovation period, which included a number of updates to meet the needs of a growing community. In 1995, St. Peter's merged with St. James to form the new St. James, covering the southern half of Jefferson County. On July 25, 2006, St. James dedicated the new parish. St. James Parish's community continues to be the one of largest in the diocese. The photograph to the left is of the old St. James Parish, and the photograph below is of the interior of the old church from 1900. (Both, courtesy of the Diocese of Wheeling-Charleston Archives.)

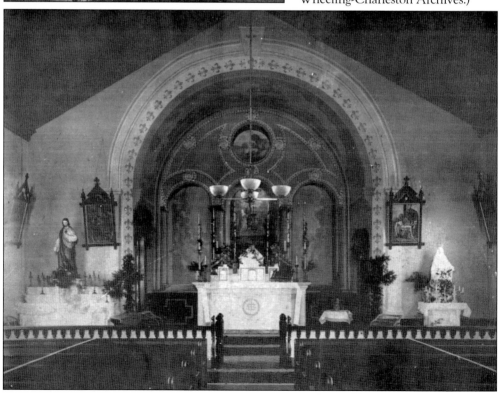

JOHN XXII PASTORAL CENTER, CHARLESTON.
The centerpiece of Bishop Joseph J. Hodges's evangelization program was the pastoral centers. Under his direction, four pastoral centers were built, each dedicated to a specific theme. The diocese intended each location to be a place of spiritual development for the people. Since their establishment in the early 1970s, they have been used to host retreats, workshops, and a variety of other programs. (Courtesy of the Diocese of Wheeling-Charleston Archives.)

ST. ANTHONY PARISH, CHARLESTON. The first members of this community were Polish immigrants who worked at the Kelly Ax Factory on the west side of Charleston. In 1908, a church was built and dedicated to the Polish patron saint, St. Ladislaus. Within 12 years, the ethnic makeup of the parish had changed from Polish to Italian. In 1920, the Italian community petitioned Bishop Patrick J. Donahue to change the church name to St. Anthony of Padua. In 1955, a larger church and rectory was built. (Courtesy of the Diocese of Wheeling-Charleston Archives.)

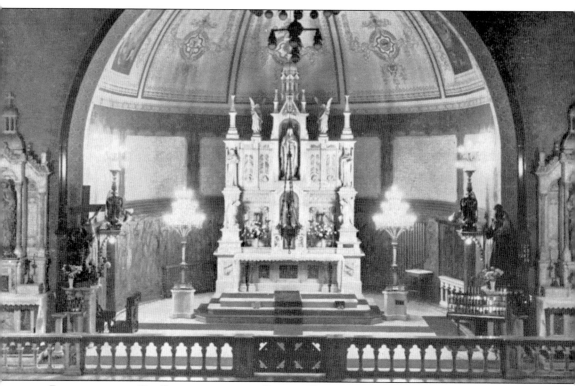

BASILICA OF THE CO-CATHEDRAL OF THE SACRED HEART PARISH, CHARLESTON. Located in the state's capital, Sacred Heart Parish was established in 1866 by the "Apostle of the Kanawha Valley," Rev. Joseph Stenger. Mass was first celebrated in a rented storefront until a church was built in 1866. The cornerstone for the present church was blessed in 1895, and the church was completed in 1897. Until 1901, diocesan priests staffed Sacred Heart. The parish was staffed by the Capuchin Friars from 1901 until 1980, when the parish was transferred back to diocesan control. From its founding until the middle of the 20th century, the priests of Sacred Heart were responsible for the ministry to Catholics in the Kanawha Valley. In 1974, Sacred Heart was designated co-cathedral of the diocese. In 2009, the Vatican elevated the co-cathedral to a basilica. The photograph is of the interior of Sacred Heart, taken in 1916. (Courtesy of the Diocese of Wheeling-Charleston Archives.)

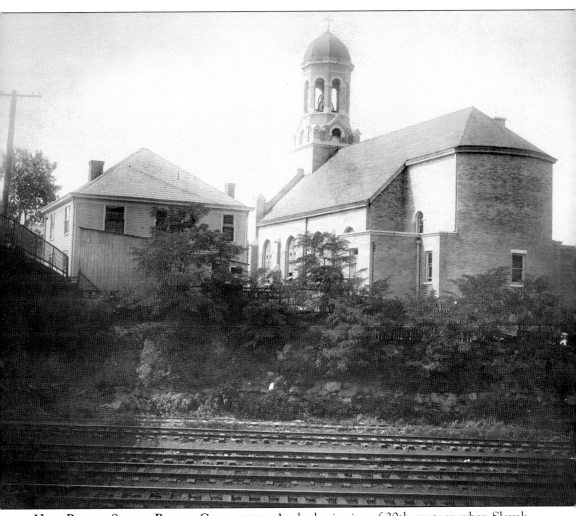

HOLY ROSARY SLOVAK PARISH, CLARKSBURG. At the beginning of 20th century, when Slovak immigrants flocked to America in large numbers, many settled in the coalfields of West Virginia, where the Consolidate Coal Company had vast holdings in Harrison County. In 1906, the Slovak community asked Bishop Patrick J. Donahue for permission to build a national Slovak parish. In 1909, the first Slovak parish was completed and dedicated by Bishop Donahue. Then, in 1924, work began on the new Holy Rosary Parish, which was dedicated by Bishop John J. Swint on July 26, 1925. Due to the shortage of priests in 1984, Holy Rosary was suppressed and incorporated with Immaculate Conception Parish in Clarksburg. The image is of the second Holy Rosary Parish and Rectory, taken in the late 1920s. (Courtesy of the Diocese of Wheeling-Charleston Archives.)

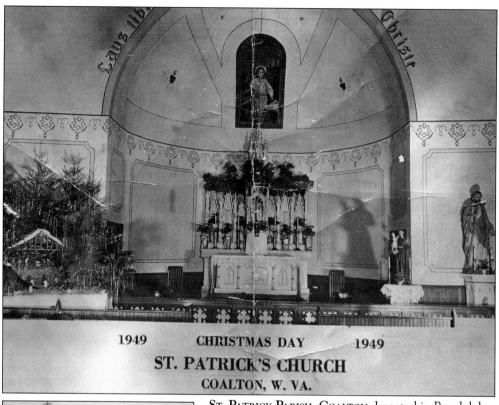

1949 CHRISTMAS DAY 1949
ST. PATRICK'S CHURCH
COALTON, W. VA.

ST. PATRICK PARISH, COALTON. Located in Randolph County, this mountain-valley town was settled by Irish immigrants in the mid-19th century and was initially known as Womelsdorf. Under the direction of Rev. Michael Fitzpatrick, the community established a church in the 1890s that was dedicated by Bishop Donahue in 1903. The image above is of the interior of that parish, taken during Christmas, 1949. (Courtesy of the Diocese of Wheeling-Charleston Archives.)

ST. BRENDAN PARISH, ELKINS. Early Catholic settlers in this mountain town of Randolph County were employed at maintenance shops of the West Virginia Central and Pittsburgh Railroad Company, as well as at the nearby coal mines and lumber mills. In 1897, a small frame church, shown here, was constructed, and it was dedicated to St. Brendan on October 28, 1900. In 1928, a second church was built to accommodate the growing community. Then, in 1999, the third and current church was constructed. (Courtesy of the Diocese of Wheeling-Charleston Archives.)

IMMACULATE CONCEPTION PARISH, FAIRMONT. The first community of worshippers gathered for mass in a vacant store in 1930. Initial members were Italian immigrants who had worked in the coal mines of Marion County and settled on the east side of the town. To preserve their traditions, they formed their faith parish community of Immaculate Conception in 1930. This photograph is of the interior of the second parish, which was built in 1960. (Courtesy of the Diocese of Wheeling-Charleston Archives.)

ST. PETER THE FISHERMAN, FAIRMONT. A Catholic presence had been established in Fairmont before 1850, but it was the Baltimore and Ohio Railroad that brought the first substantial influx of Catholics to the region. In 1857, the first St. Peter's Church was established. Due to the increased population of Catholics following the development of more coalfields, a second parish was completed and dedicated in the early 1900s. In 1998, St. Peter's and St. Joseph Parish were incorporated to form St. Peter the Fisherman Parish. (Courtesy of the Diocese of Wheeling-Charleston Archives.)

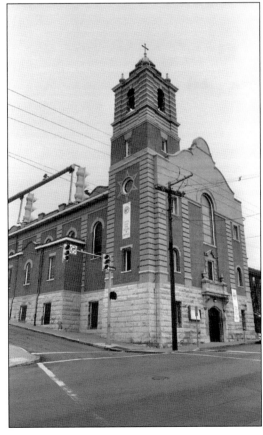

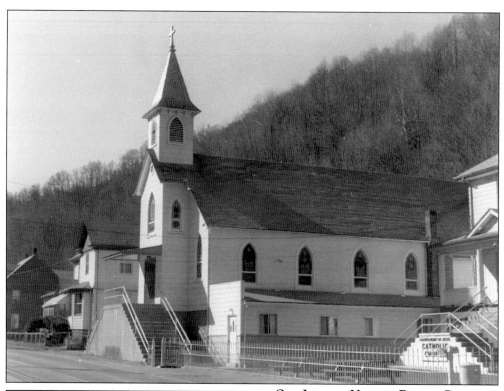

OUR LADY OF VICTORY PARISH, GARY. Our Lady of Victory Parish came into being through the efforts of Rev. Emil Olivier. After offering mass at the home of Hugh Dillon, he arranged with the U.S. Coal and Coke Company to donate the property where Our Lady of Victory was built in 1904. However, three years later, a fire destroyed the church. In 1909, the second, and current, parish was built. The above photograph of the church was taken in the 1970s. (Courtesy of the Diocese of Wheeling-Charleston Archives.)

ST. THOMAS PARISH, GASSAWAY. St. Thomas Parish was established as a mission in 1908. The church was a gift of industrialist Richard Kerens in memory of his father. The Marist Fathers from Richwood served the St. Thomas community from its inception until 1973, when it became an independent church. (Courtesy of the Diocese of Wheeling-Charleston Archives.)

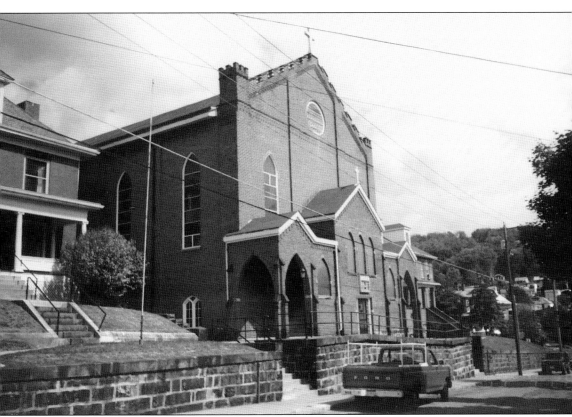

St. Augustine Parish, Grafton. The community of St. Augustine was established in 1852 to serve the Irish laborers of Grafton's Baltimore and Ohio Railroad shop. The simple frame church was built in 1857 and was replaced in 1872 with the current brick church. Over its history, St. Augustine's has served as the center of Catholic activity for this region of the diocese. (Courtesy of the Diocese of Wheeling-Charleston Archives.)

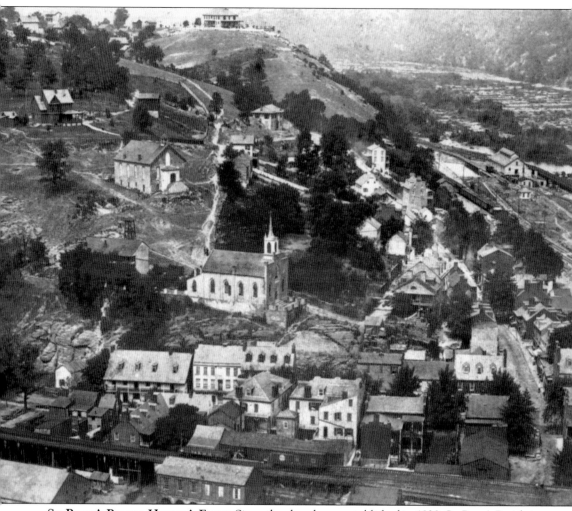

St. Peter's Parish, Harper's Ferry. Since the church was established in 1830, St. Peter's Parish in Harper's Ferry has been the focal point for some the most significant events in American history, particularly the American Civil War. During the Civil War, Rev. Michael A. Costello remained at his post and guarded the parish. At the end of the war, St. Peter's was the only untouched structure in Harper's Ferry. In 1889, the parish was renovated and restored. In 1995, the parish was incorporated with St. James Parish in Charles Town. Today the church is a national landmark and remains an important fixture in the Harper's Ferry community. St. Peter's Parish is surrounded by the city of Harper's Ferry and is located near the center of the photograph. (Courtesy of the Diocese of Wheeling-Charleston Archives.)

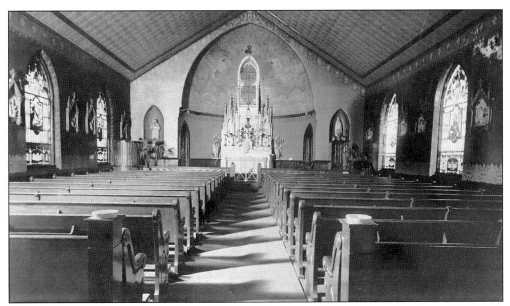

ST. PATRICK PARISH, HINTON. Rev. D. P. Walsh organized St. Patrick Parish in 1874. Irish immigrants, who had worked on the Chesapeake and Ohio Railroad, were the initial members. Others came to the area to work in the coal mines. The first church, a one-story frame house, was built by 1878 and later converted into the rectory when the second church was built in 1899. In this picture, taken in 1930, is the interior of the second parish. (Courtesy of the Diocese of Wheeling-Charleston Archives.)

ST. JOSEPH PARISH, HUNTINGTON. In 1872, Bishop Richard V. Whelan sent Rev. Thomas A. Quirk to organize the Catholics of Cabell County. He established two parishes, St. Peter Parish in Guyandotte and St. Joseph Parish in Huntington. The first St. Joseph Parish was built at Twentieth Street and Eighth Avenue. In 1889, Rev. John Werninger built the second church. In this picture is the interior of the church, which is decorated for Christmas. (Courtesy of the Diocese of Wheeling-Charleston Archives.)

CHURCH OF THE ASSUMPTION, KEYSER. Founded in 1874, Assumption Parish was the first Catholic community in Mineral County. Rev. Jeremiah O'Sullivan from Westernport, Maryland, oversaw the construction of the first church. The second, built in Gothic style, was dedicated in 1906. Parishioners, including immigrants who had been master stonecutters in Italy, donated much of the labor. (Courtesy of the Diocese of Wheeling-Charleston Archives.)

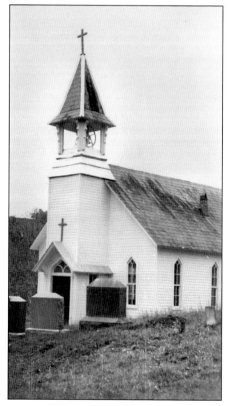

ST. BERNARD PARISH, LOVEBERRY. St. Bernard Parish was built in 1910 on Loveberry Hill, near Weston, West Virginia. Msgr. Thomas A. Quirk served the parish community for 53 years and is buried in the cemetery next to the church. Monsignor Quirk was a well-known figure in the area and an important part of the history of the diocese. Monsignor Quirk lived to be 92 years old. (Courtesy of the Diocese of Wheeling-Charleston Archives.)

ST. PATRICK PARISH, MANNINGTON.
St. Patrick Parish in Mannington
began as a mission of Assumption
of the Blessed Virgin Mary Parish
in Littleton. It was organized to
serve Irish immigrants who were
laying track from Baltimore, through
the Appalachian Mountains, to
Wheeling. The first church was
built in 1867, and in 1907, a second
parish, with beautiful Austrian
stained-glass windows, was built.
(Courtesy of the Diocese of
Wheeling-Charleston Archives.)

ST. STANISLAUS KOSTKA, MONONGAH.
A national Polish parish, Stanislaus
Kostka was founded in 1905. Due
to the church's declining numbers,
Bishop Joseph H. Hodges merged
the parish in 1975 with Our Lady
of Pompeii, another parish located
in close proximity. These two
parishes formed Holy Spirit Parish,
which was dedicated in 1982. This
picture, taken in 1916, shows the
parish with the up-and-coming city
of Monongah in the background.
(Courtesy of the Diocese of
Wheeling-Charleston Archives.)

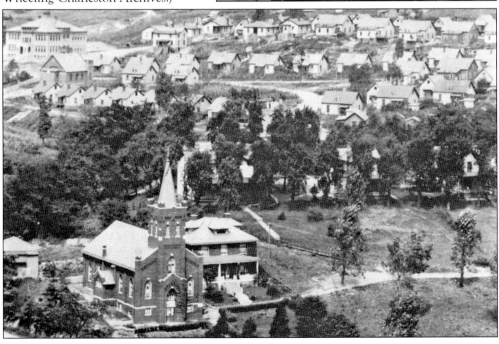

ST. MARGARET MARY PARISH, PARKERSBURG. By 1918, the growing number of Catholics in Parkersburg persuaded Bishop Patrick Donahue to establish a second parish. Property was purchased in north Parkersburg, and a temporary chapel was built. The first mass was celebrated on Palm Sunday, 1923. The parish was eventually opened in September 1923 and dedicated by Bishop John J. Swint on December 21, 1924. The current parish, shown in this picture, was dedicated on May 23, 1993. (Courtesy of the Diocese of Wheeling-Charleston Archives.)

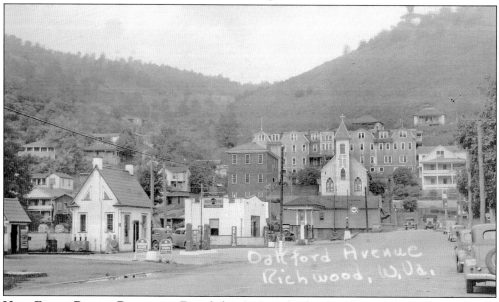

HOLY FAMILY PARISH, RICHWOOD. Founded as St. Joseph, the Guardian of the Holy Family, the church traces its origin to 1899, when a lumber company sent Calvin Amos to a mill in Richwood, Randolph County. Reverend DiLoan of Weston first offered mass in Amos's home in 1902. R. M. Dyer donated property for a church in 1905, and Bishop Patrick Donahue dedicated it on August 26, 1906. This picture, taken in 1939, shows the parish in the background. (Courtesy of the Diocese of Wheeling-Charleston Archives.)

ST. MARY (IMMACULATE CONCEPTION) PARISH, SOUTH WHEELING. The foundation of Immaculate Conception Church on the corner of Thirty-Sixth and Woods Streets was dug in 1872, and on July 14, the laying of the cornerstone took place. One year later, in 1873, the parish was dedicated. However, in 1875, a fire destroyed the interior of the parish. Within a year, a new church was built, and it was dedicated on August 19, 1876. The new parish served the predominantly Irish Catholic community of South Wheeling. In 1995, this parish and St. Ladislaus was incorporated with St. Alphonsus Parish. This picture shows what the parish looked like in the 1950s. (Courtesy of Charles F. Gruber Studios.)

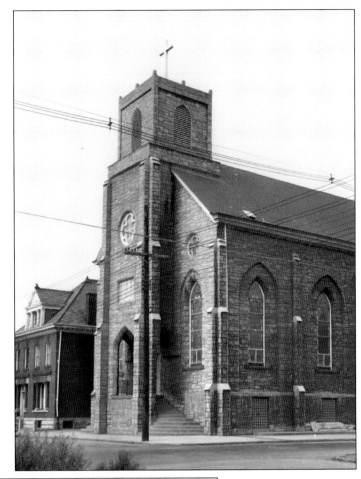

ST. MARY'S SCHOOL, SOUTH WHEELING. Built in 1897 by St. Mary's Parish, St. Mary's School served the South Wheeling community until 1968. The school had four classrooms and held two grades in each room on the first floor. A gymnasium, a stage, and a kitchen were on the second floor of the building. Due to maintenance costs, the school was razed. (Courtesy of Charles F. Gruber Studios.)

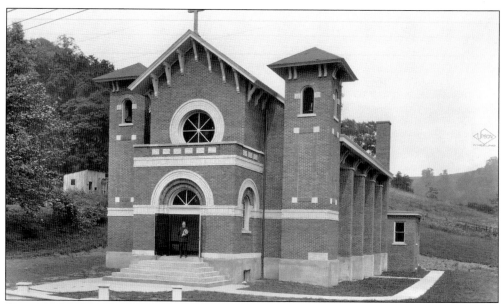

OUR LADY OF SEVEN DOLORS MISSION, TRIADELPHIA. This Catholic presence in the Wheeling area is associated with the arrival of Irish laborers, employed on the National Road and Hemfield Railroad projects. Construction of the first church began in 1824, but the church wasn't completed until 1869. In 1896, the church became a mission of St. Vincent de Paul Parish in Elm. The present brick church was built in 1924. This photograph was taken in 1925. (Courtesy of the Diocese of Wheeling-Charleston Archives.)

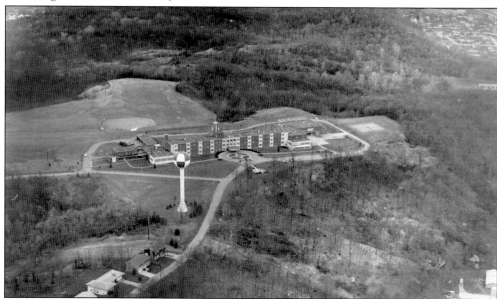

ST. JOSEPH PREPARATORY SEMINARY, VIENNA. To help promote religious vocations in the diocese, Archbishop John J. Swint undertook the construction of a seminary in 1962. Property in Vienna was purchased to construct the St. Joseph Preparatory Seminary, and the first class of students arrived in the fall of 1963. For the next 24 years, this institution offered high school seminary education to over 400 young men. This photograph, taken in 1974, shows the seminary campus. (Courtesy of the Diocese of Wheeling-Charleston Archives.)

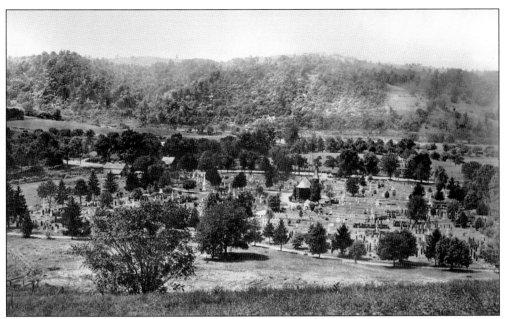

MOUNT CALVARY CEMETERY, WHEELING. Prior to the 1872 establishment of Mount Calvary Cemetery on National Road in Wheeling, burials were made in the Catholic cemetery in the Manchester addition of Wheeling, along Rock Point Road. Shortly after Mount Calvary was established, the bodies were moved from Manchester to Mount Calvary, which at the time was comprised of 40 acres. In 1941, the Krieger property of approximately 48 acres was acquired. This photograph, taken in 1899, shows the layout of the original 40 acres of the cemetery. (Courtesy of the *West Virginia Catholic Register.*)

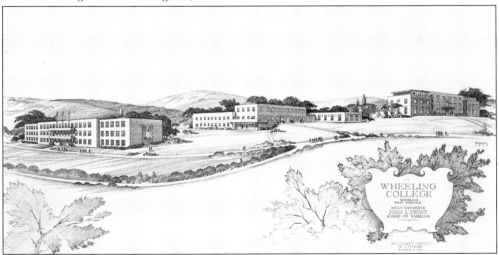

WHEELING COLLEGE, WHEELING. In early 1950s, Archbishop John J. Swint, with the funds provided by the late Sarah Tracy, established the first Catholic college in the diocese. The Jesuit Fathers accept Archbishop Swint's invitation to administer the college. The 60 acres of land for the new college was purchased by the diocese from the Visitation nuns of Mount de Chantal Visitation Academy. Wheeling College (now Wheeling Jesuit University) was established as a coeducational liberal arts college in the Jesuit tradition. This is the architect's drawing of the future campus. (Courtesy of the *West Virginia Catholic Register.*)

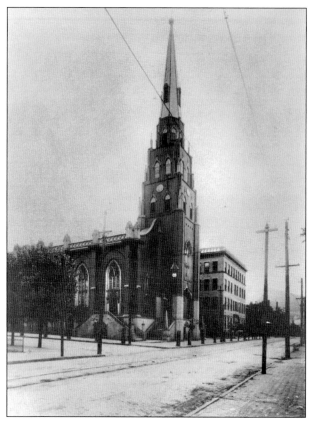

OLD ST. JAMES CATHEDRAL, WHEELING. St. Joseph Cathedral, completed in 1823, was the first church built in the diocese. Initial members of the parish were primarily Irish and German immigrants. A second framed church was built in 1849. When the Diocese of Wheeling was established in 1850, St. James became the cathedral parish. The name of the parish was officially changed to St. Joseph in 1872. The photograph to the left, taken in the early 1900s, shows the exterior of the original 1849 St. James Parish. The photograph below, taken in the early 1900s, shows the interior of the original St. James Parish. (Both, courtesy of the Diocese of Wheeling-Charleston Archives.)

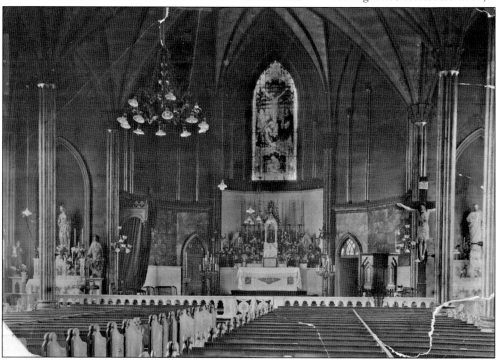

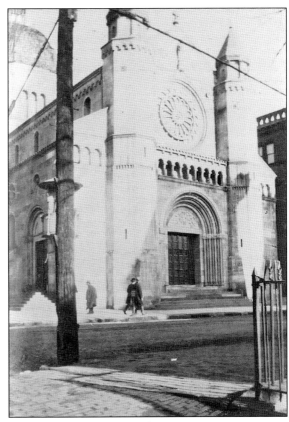

CATHEDRAL OF ST. JOSEPH, WHEELING. In 1923, the old cathedral was razed, and a temporary chapel was constructed for parishioners until the new cathedral was constructed. On May 5, 1924, Bishop John Swint blessed the cornerstone for the new cathedral. The new cathedral, built entirely of Indiana limestone, was completed within two years and consecrated on April 21, 1926. In 1995, Bishop Bernard Schmitt renovated and updated the cathedral. It was rededicated on August 16, 1996. The two photographs, taken in 1926, show the exterior and interior of the new Cathedral of St. Joseph. (Both, courtesy of the Diocese of Wheeling-Charleston Archives.)

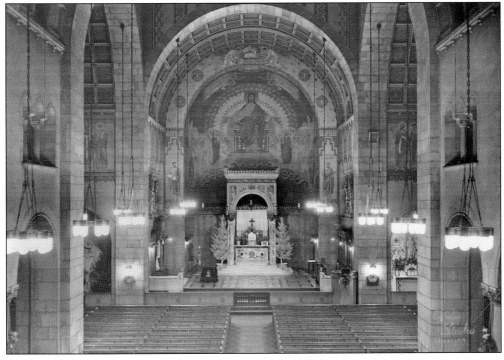

OLD CHANCERY OFFICE, WHEELING.
Since the founding of the diocese
in 1850, the seat has always been in
Wheeling. The photograph, taken
in the 1960s, shows the old chancery
office. (Courtesy of the Diocese of
Wheeling-Charleston Archives.)

ST. ALPHONSUS PARISH, WHEELING. St.
Alphonsus Parish was established in
1856 to serve the German community
in Wheeling. Diocesan priests staffed
the parish until the Capuchin Friars
arrived in 1884. They remained at the
parish until 1994, which was when it was
transferred back to diocesan control. The
present church was built in 1886 and
is noted for its stained-glass windows,
woodcarvings, and unique statuary. It
was placed on the National Register
of Historic Places in 1988. In 1995, St.
Ladislaus Parish (Polish) and St. Mary
Parish (Irish) were incorporated into
the parish. The photograph, taken
prior to 1886, shows the original St.
Alphonsus Parish, as well as its long
wooden steeple. (Courtesy of the Diocese
of Wheeling-Charleston Archives.)

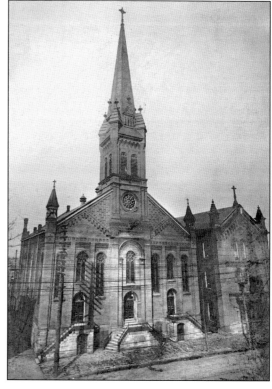

COLUMBIA CLUB, WHEELING. Started in 1898, the Columbia Dramatic and Musical Club was a fraternal social organization. The Columbia Club Building, built in 1911, was right across the street from the St. Alphonsus parish on Market Street. The building included a social hall, meeting room, auditorium, and a bowling alley in the basement. From 1918 to 1929, it also housed the Columbia Commercial College, taught by the Christian Brothers of De LaSalle. The building was razed in 1973. The two photographs, taken in 1911, show the exterior and interior of this club. (Both, courtesy of the Diocese of Wheeling-Charleston Archives.)

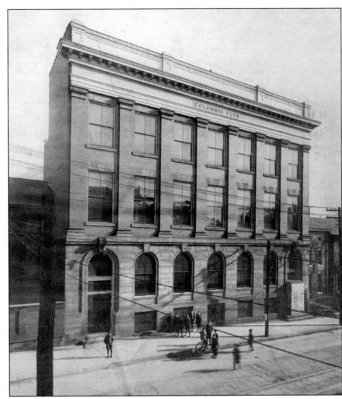

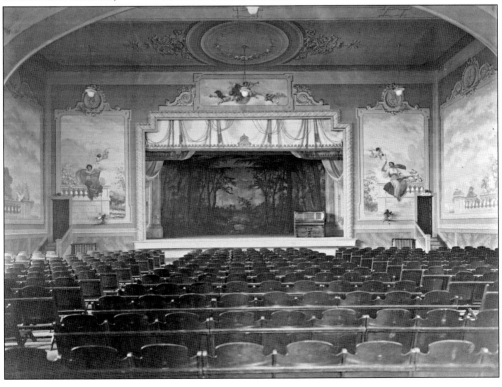

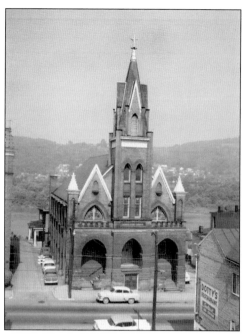

SACRED HEART PARISH, WHEELING. Shortly after the end of the 19th century, the city of Wheeling and the Catholic Church suddenly found themselves expanding in every direction. The population of the north side of Wheeling was growing, and industry was moving northward. In 1903, a wealthy woman by the name of Kate Andrews from New York offered Bishop Patrick J. Donahue a contribution of $10,000 to erect a new parish in North Wheeling on the condition that it would be called Sacred Heart. In 1995, Sacred Heart Parish was incorporated into the Cathedral of St. Joseph. The photograph, taken in the 1950s, shows the front of the church. (Courtesy of Charles F. Gruber Studios.)

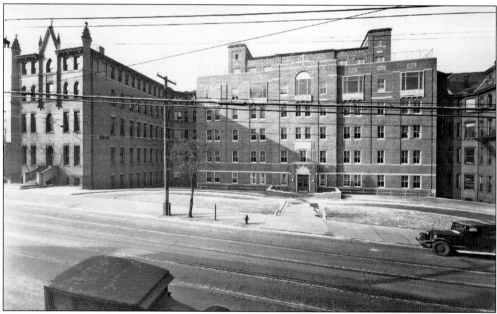

NORTH WHEELING HOSPITAL, WHEELING. Located next to Sacred Heart Parish in north Wheeling was North Wheeling Hospital. Founded by Bishop Richard V. Whelan in 1850, Wheeling Hospital suffered from a lack of staff and administration. Concerned over this matter, Bishop Whelan petitioned the Sisters of St. Joseph to establish a convent in the diocese and to take over the hospital. In the 1970s, a new hospital complex was built in the Clator section of Wheeling. Under their care and direction, Wheeling Hospital went on to become one of the most respected medical institutions in the state and one of the most visible symbols of the Catholic presence here. This photograph of the hospital was taken in 1930. (Courtesy of the Diocese of Wheeling-Charleston Archives.)

St. Joan of Arc Parish, Wheeling. The history of St. Joan of Arc Parish goes back to the early 1920s. The first pastor, Fr. Jeremiah O'Connell, had the combination parish and school constructed on Joan Street in 1923. In 1995, St. Joan of Arc Parish was incorporated into the Cathedral of St. Joseph. The photograph, taken in the 1950s, shows the exterior of the church. (Courtesy of Charles F. Gruber Studios.)

St. John's Home for Boys, Wheeling. Since their arrival in 1853, the Sisters of St. Joseph have played an important role in health and education in the community. Along with staffing Wheeling Hospital, the sisters also expressed a desire to establish orphanages. At that time, an orphanage was created as a department at Wheeling Hospital. When it was designated a separate institution, the orphanage relocated to Elm Grove and was renamed St. Vincent's Home for Girls in 1894. Meanwhile, the sisters had opened St. John's Home for Boys, also located in Elm Grove, in 1887. In 1975, the mission of both institutions changed to work with children from troubled homes and was renamed St. John's Home for Children, which still operates today. The photograph shows the original St. John's Home for Boys. (Courtesy of Charles F. Gruber Studios.)

St. Ladislaus Parish, Wheeling. St. Ladislaus was the first of five Polish national parishes founded in the diocese. Members of Wheeling's growing Polish community petitioned Bishop Patrick J. Donahue in 1902 for permission to establish their own parish. The Polish community of South Wheeling, right across from St. Alphonsus Parish, purchased property. Bishop Donahue dedicated St. Ladislaus Parish in 1903. The parish was incorporated into St. Alphonsus Parish in 1995. This photograph, taken in the 1950s, shows the parish at the height of its time. (Courtesy of Charles F. Gruber Studios.)

Three

THE PEOPLE

The uniqueness of Catholic West Virginia lies in the diversity of its people. Throughout the history of the diocese, people from all walks of life have been instrumental in creating communities where faith is the focus of their lives. Whether in Wheeling, Charleston, or Huntington, these photographs illustrate how these early immigrants not only brought with them their traditions but also instituted their Catholic values. These values included family, hard work, prayer, reverence, and honesty. This set of principles has been the guiding focus behind these early communities. Behind the principles is the church, which serves as the foundation of the cohesiveness visible between children, adults, and their clergy. The photographs in this chapter bring to life the endurance of Catholic values and principles that still hold true today.

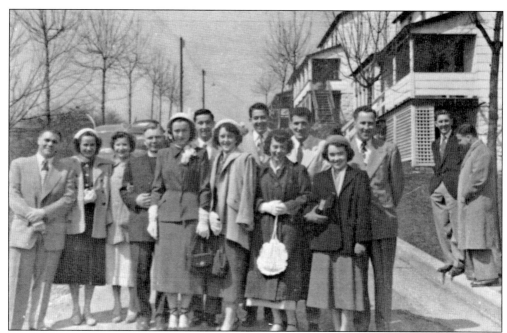

EASTER CHOIR, 1950. For the Catholic Church, Easter Sunday is a special time of the year. In this picture, taken on April 9, is the Easter Sunday Choir in front of All Saints Parish. In the first row, on the far right, is the parish organist, Claire Kennedy. (Courtesy of the Diocese of Wheeling-Charleston Archives.)

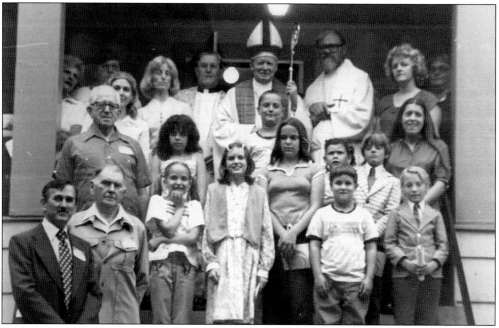

RESURRECTION MISSION, C. 1980. Members and friends of this mission community stand in front of Resurrection Mission. At this event is Bishop Joseph H. Hodges (top center), Rev. Mark Kraus (to the left of the bishop), and Sister Theresa Reddington, SSJ, director of Resurrection Mission (to the left of Reverend Kraus). (Courtesy of the Diocese of Wheeling-Charleston Archives.)

MAY QUEEN, 1940. The small group of children assembled in front of St. John Parish is part of the annual May Queen ceremony. In this photograph, the May Queen is Dora Vecchione (second row, center), with little Peggy Bartels standing in front of Dora and Bill Bartels, who is to the right of Peggy. (Courtesy of the Diocese of Wheeling Charleston Archives.)

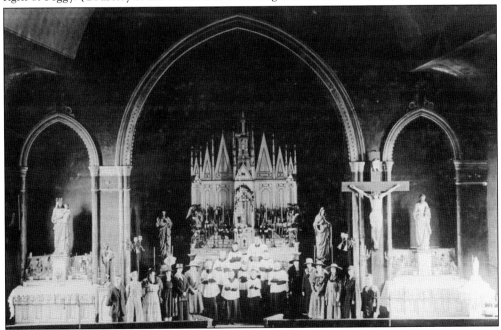

ALTAR AND INTERIOR, C. 1900. This image of the interior of St. John Parish clearly shows the true beauty of this one-of-a-kind parish. Pictured on the altar are members of the parish community. (Courtesy of the Diocese of Wheeling Charleston Archives.)

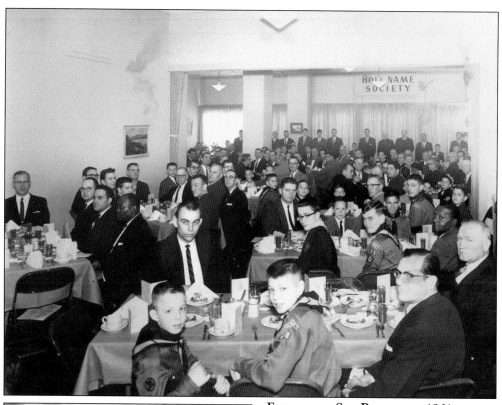

FATHER AND SON BREAKFAST, 1961.
The local Boy Scout troop of the Sacred
Heart Parish in Bluefield has organized
the annual Father and Son Breakfast,
held on February 12. (Courtesy of the
West Virginia Catholic Register.)

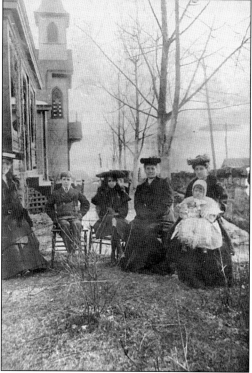

FIRST CHURCH AND RECTORY, 1895.
Taken in front of the first church and
rectory of Sacred Heart Parish in Bluefield
are members of the parish community.
Seated, from left to right, are Jennie Sadler,
the church organist; John ?; Josephine
?; Ann Stack Sadler; Mrs. Cassidy; and
little Mary ?. (Courtesy of the Diocese
of Wheeling-Charleston Archives.)

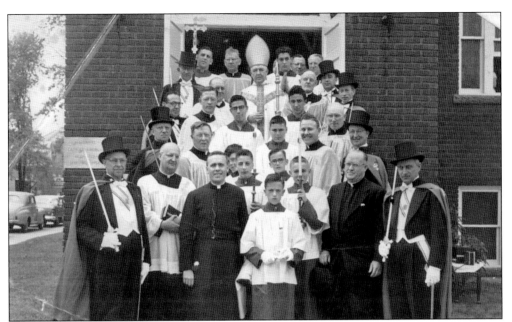

DEDICATION OF ALL SAINTS PARISH, 1954. On May 16, the proud parishioners of All Saints Parish in Bridgeport welcomed Coadjutor Bishop Thomas J. McDonnell, who officiated over the dedication of the new church. Bishop McDonnell and Fr. Robert Nash (bottom left) are surrounded by members of the parish and the Knights of Columbus. (Courtesy of the Diocese of Wheeling-Charleston Archives.)

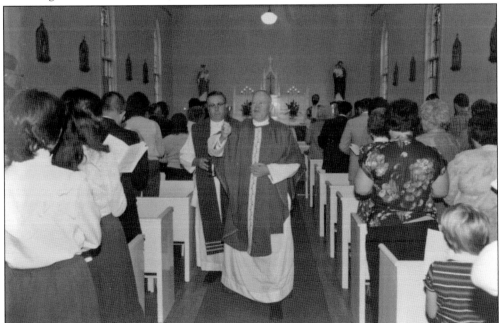

THE 50TH ANNIVERSARY OF ST. WILLIAM MISSION, 1982. The parishioners of St. William Mission in Cairo celebrate their 50th anniversary. In this photograph, taken on September 26, 1982, Bishop Joseph H. Hodges blesses the congregation with Msgr. Robert Nash (on the Bishop's left), the chancellor of the diocese. (Courtesy of the Diocese of Wheeling-Charleston Archives.)

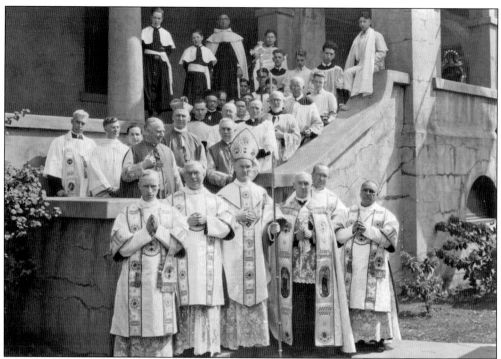

CARMELITE MONASTERY, 1925. The Carmelite Sisters of the Carmelite Monastery in Wheeling celebrate Solemn Triduum Blessed Therese of the Child Jesus during a three-day ceremony on September 27, 28, and 29, 1925. Members of the clergy and altar boys are pictured in front of the monastery after the Solemn Pontifical Mass on Sunday, September 29, 1925. From left to right in the front row are Fr. Mickey Caughlin with Fr. Jerry O'Connor, Bishop John J. Swint, and Fr. Owen Lennon, a chaplain to Bishop John J. McCort of the Diocese of Altoona, Pennsylvania. Seated at the table below are members of the clergy at the reception after the mass. (Both, courtesy of the Carmelite Sisters of the Carmelite Monastery Archives.)

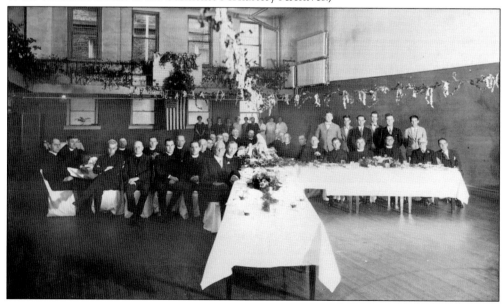

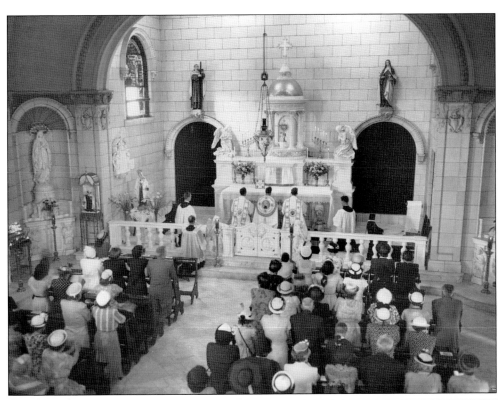

THE 50TH ANNIVERSARY OF THE CARMELITE MONASTERY, 1963. Bishop Patrick J. Donahue dedicated the Carmelite chapel on October 24, 1915. The chapel opened for public devotion services in 1916. The monastery's 50th Jubilee services were held over several days to honor Our Lady of Mount Carmel and to celebrate the anniversary of their founding in Wheeling. In 1975, the Carmelite nuns left Wheeling. (Courtesy of the Carmelite Sisters of the Carmelite Monastery Archives.)

CATHEDRAL OF ST. JOSEPH, 1969. Pictured on July 8, 1969, Rev. John T. Mueller, rector of St. Joseph Cathedral, is aided by some much-needed helpers in cleaning and organizing the cathedral. (Courtesy of the Diocese of Wheeling-Charleston Archives.)

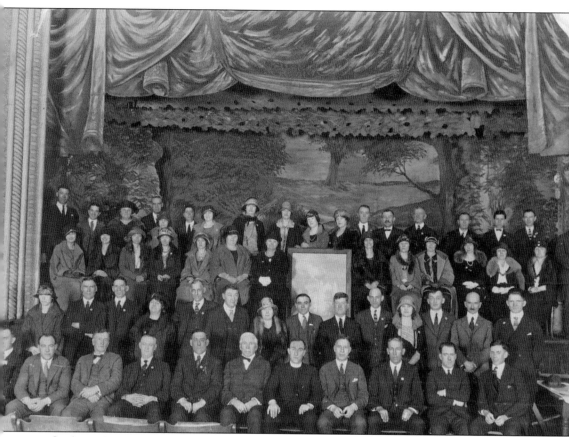

CARROLL CLUB, 1923. This picture shows the members of the Cathedral Planning Committee, Carroll Council No. 504 of the Knights of Columbus. Some of the members of the Carroll Council included Richard Callan (first row, fourth from the left) and a Mr. Bernhart (second row, third from the left), who was the custodian of the cathedral. His daughter Adelaide is to his left. The Carroll Council, which was chartered on April 29, 1900, was the first unit of the Knight of Columbus in West Virginia. Along with being involved in fraternal and social affairs, the Carroll Council took over all lay committees' duties. Some of these committees were in charge of the decorating and cleaning of St. Joseph's Cathedral and sending out press releases and pictures of the visiting dignitaries to every paper. (Courtesy of the Diocese of Wheeling-Charleston Archives.)

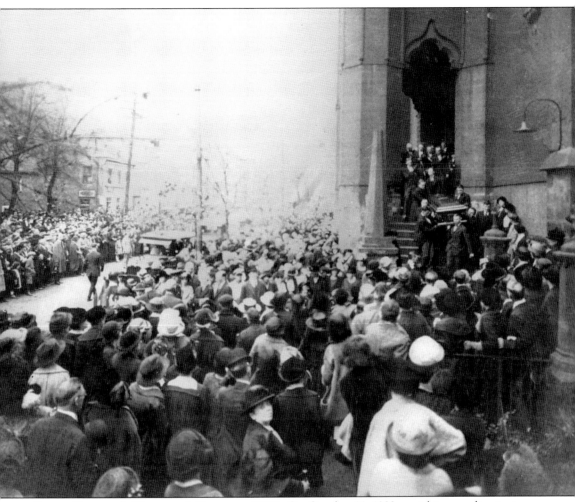

Bishop Patrick J. Donahue's Funeral, 1922. On October 11, 1922, parishioners, dignitaries, clergy members, family, and friends from all over the state and around the country came to pay their final respects to a bishop who was called "The Immigrant Bishop." In a fitting send-off to this faithful servant and leader of the diocese, parishioners gather outside St. Joseph Cathedral as the casket of Bishop Donahue is taken to its final resting place at Mount Calvary Cemetery. (Courtesy of the Diocese of Wheeling-Charleston Archives.)

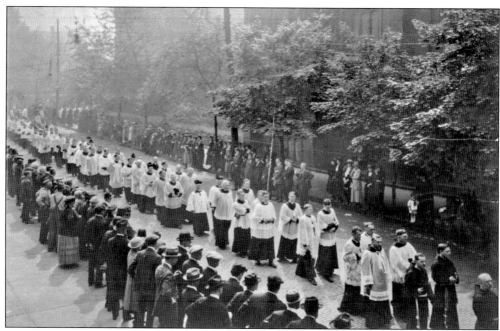

ORDINATION OF BISHOP JOHN J. SWINT, 1922. Two months after the death of Bishop Patrick J. Donahue, Bishop John J. Swint was ordained and installed as the fourth bishop of Wheeling-Charleston at St. Joseph in Wheeling. At this ceremony on December 11, 1922, members of the diocese and Wheeling community line up outside at the corner of Thirteenth and Eoff Streets to watch Bishop Swint proceed to the cathedral. In these photographs, the cathedral rectory, St. Joseph Cathedral, and surrounding buildings can be seen in the background. (Both, courtesy of the Diocese of Wheeling-Charleston Archives.)

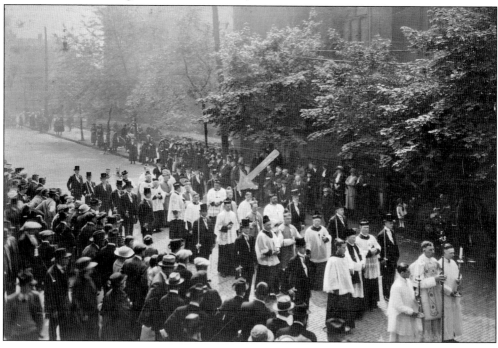

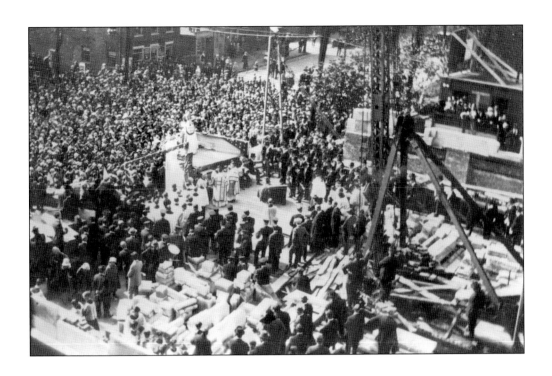

BLESSING OF THE FOUNDATION, 1924. In 1923, after 75 years of service, the second St. Joseph Cathedral was razed for a new cathedral. On May 5, 1924, a large ceremony and mass were held by Bishop John J. Swint to bless the cornerstone of the new cathedral. Two years later, the new St. Joseph Cathedral was completed. (Both, courtesy of the Diocese of Wheeling-Charleston Archives.)

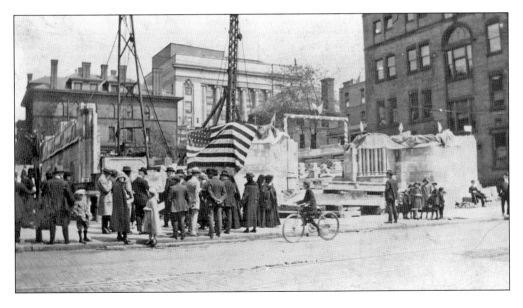

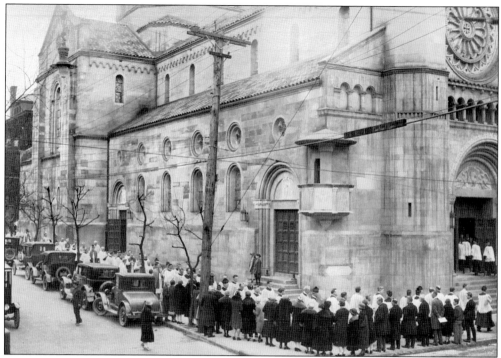

CONSECRATION OF THE NEW CATHEDRAL, 1926. On April 21, 1926, the new and beautiful, limestone-constructed cathedral was consecrated by Bishop John J. Swint. As clergy and parishioners process into the cathedral, two young boys can be seen taking in this historic event. (Courtesy of the Diocese of Wheeling-Charleston Archives.)

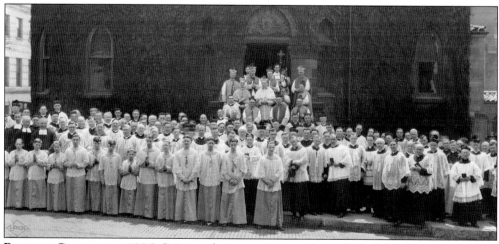

RECTORY GATHERING, 1926. Prior to the procession to the cathedral for the consecration, members of the clergy, altar boys, and Bishop John J Swint take a group photograph in front of the cathedral's rectory. (Courtesy of the Diocese of Wheeling-Charleston Archives.)

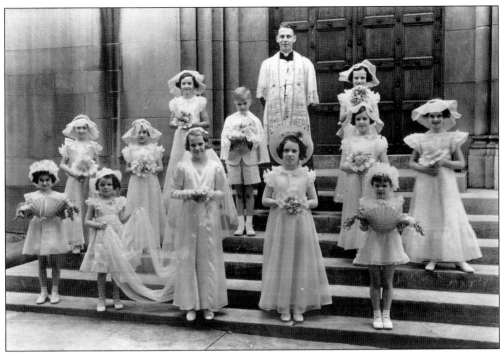

MAY QUEEN PROCESSION, C. 1930. Pictured in front of the St. Joseph Cathedral with Rev. William J. Lee, rector of the cathedral, are girls dressed in festive spring dresses and bonnets for the annual May Queen procession. (Courtesy of the Diocese of Wheeling-Charleston Archives.)

MOUNT ST. JOSEPH, 1978. Pictured in front of the Motherhouse are members of the Congregation of the Sisters of St. Joseph in Wheeling. On May 4, 1860, the sisters became the first and only religious order to be incorporated in the diocese. (Courtesy of Charles F. Gruber Studios.)

CORNERSTONE LAYING, 1925. The community of Chester, West Virginia, witnessed the cornerstone laying of Sacred Heart Church on September 20, 1925, by the Right Reverend John J. Swint, Divinitatis Doctor (D.D.), bishop of the Diocese of Wheeling. Bishop Swint was assisted by the following: Rev. Edward Weber, D.D., monsignor and chancellor of the diocese; Rev. Leopold Hermans, dean, Wellsburgh, West Virginia; Rev. Andrew Wilczek of Weirton, West Virginia; Rev. Frederick Schwertz, assistant chancellor; Rev. William J. Sauer, pastor; Rev. Thomas Walsh of East Liverpool, Ohio; and Rev. Father Ruffing of Wellsville, Ohio. Located at the tip of the Northern Panhandle, Sacred Heart was the first church established in Hancock County. (Both, courtesy of the Diocese of Wheeling-Charleston Archives.)

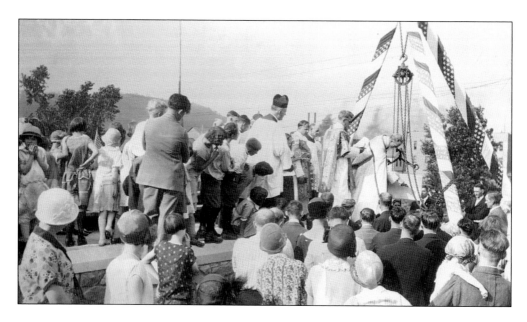

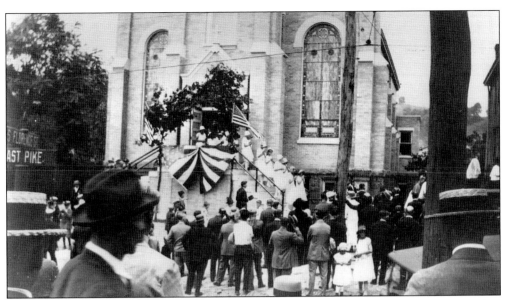

DEDICATION OF HOLY ROSARY PARISH, 1925. On a warm and sunny July 25, 1925, the community of Clarksburg gathered at the corner of South Florence Street and East Pike for the dedication of Holy Rosary Parish. (Courtesy of the Diocese of Wheeling-Charleston Archives.)

DEDICATION OF THE CELTIC CROSS, 1962. Standing on the consecrated sod of old Ireland at the foot of the big Celtic cross at Coalsburg are Charles Meade Willis and Virginia Banks Willis. They are the great-grandnephew and great-grandniece of the man who brought the cross and the sod from Ireland for the Irish of Kanawha County on St. Patrick's Day, 1912, 50 years before. (Courtesy of the *West Virginia Catholic Register.*)

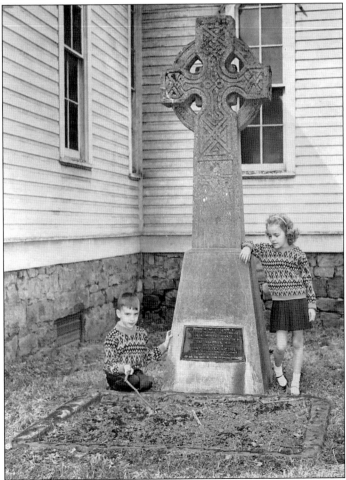

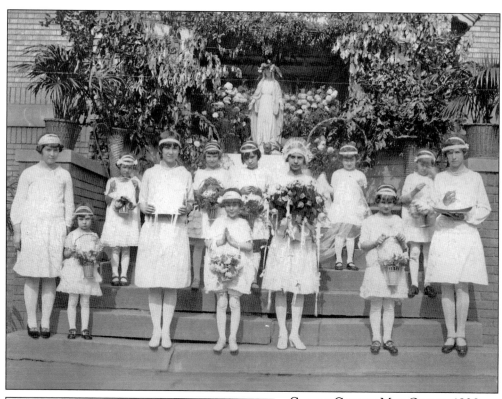

CORPUS CHRISTI MAY QUEEN, 1928. Standing in front of the St. Mary statue are the girls from of the annual May Queen festival at Corpus Christi Parish. The taller girls in the front row are, from left to right, Rose Murphy; Aimee Flynn; Rosella Beck, the 1928 May Queen; and Edith Carroll. (Courtesy of the Diocese of Wheeling-Charleston Archives.)

FORREST FESTIVAL, 1970s. Standing inside the St. Brendan's Rectory in Elkins with Rev. R. M. Kraus is Queen Sylvia. They, along with other guests, are celebrating the annual Forrest Festival. (Courtesy of the Diocese of Wheeling-Charleston Archives.)

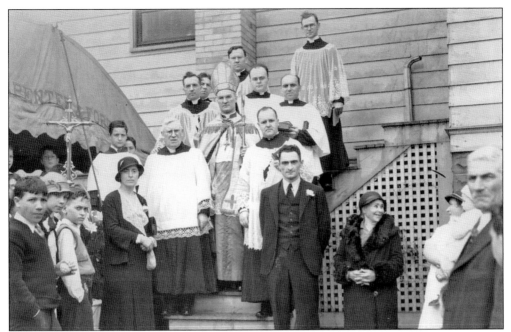

DEDICATION, 1933. Assembling on the steps of the Italian mission at Watson are the parishioners of the new mission. In 1930, Bishop John J. Swint dedicated this site, which was the centerpiece to the large Italian mining community of Watson. This mission eventually became St. Anthony Parish in Fairmont. (Courtesy of the Diocese of Wheeling-Charleston Archives.)

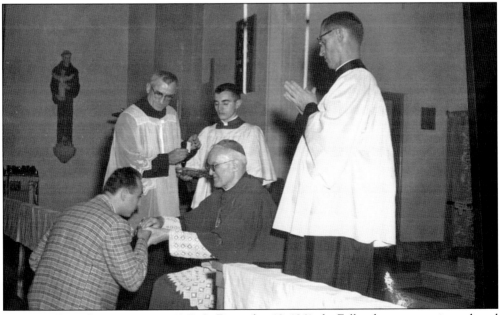

BUILDING FUND INAUGURATION, 1961. In December 12, 1961, the Follansbee community gathered at the inauguration of the St. Anthony Parish Fund. The fund was to raise money for the All Purpose Catholic Center in Hoover Heights. Present at mass was a frail Archbishop Swint with Fathers John L. O'Reilly (left) and John Allison (right) at his sides. (Courtesy of the Diocese of Wheeling-Charleston Archives.)

RELIGIOUS TEACHERS CERTIFICATE DINNER, 1985. Volunteers are hard at work in the St. Anthony Parish kitchen in Follansbee serving dinner for the Annual Religious Teachers Certificate Program. (Courtesy of the Diocese of Wheeling-Charleston Archives.)

A NEW CHURCH, 1970. On June 14, 1970, the community of Glendale gathers for the dedication mass for St. Jude Parish. Presiding over the dedication was Bishop Joseph H. Hodges with Fr. A. James Myles and Fr. John Lester. (Courtesy of the Diocese of Wheeling-Charleston Archives.)

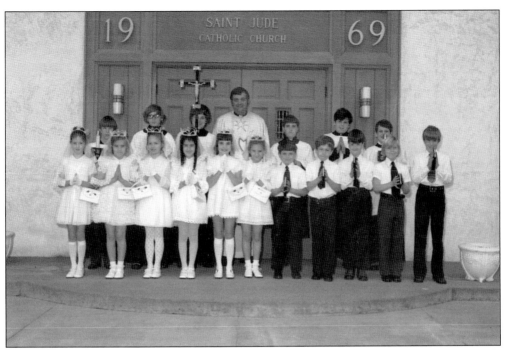

FIRST COMMUNION, 1972.
In this group picture, taken in front of St. Jude Parish, children are about to take their First Holy Communion. Pictured with them is Fr. James Myles, pastor of the parish. (Courtesy of the Diocese of Wheeling-Charleston Archives.)

OUTDOOR RETREAT, 1980.
Members of Christ in the Hill go into the woods for an outdoor retreat with Fr. Joe Peschel and Fr. Rob Currie (seated in the center). (Courtesy of the Diocese of Wheeling-Charleston Archives.)

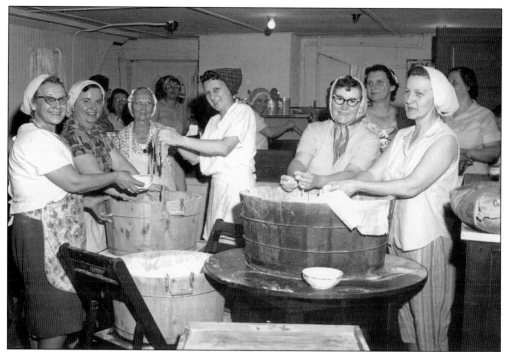

PIEROGIES, 1950s. The Polish women of St. Ladislaus Parish in Wheeling prepare traditional pierogies in the parish kitchen. This was customary for church holidays and get-togethers. (Courtesy of Charles F. Gruber Studios.)

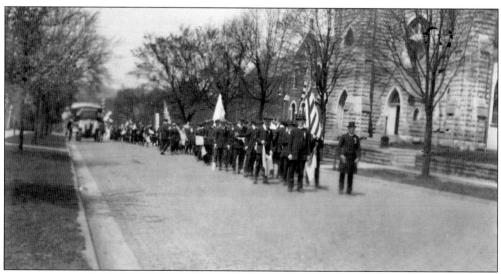

PARADE, 1920. In front of St. Joseph Parish in Huntington is a patriotic parade marching down Sixth Avenue. The men in front look to be priests from the parish. (Courtesy of the Diocese of Wheeling-Charleston Archives.)

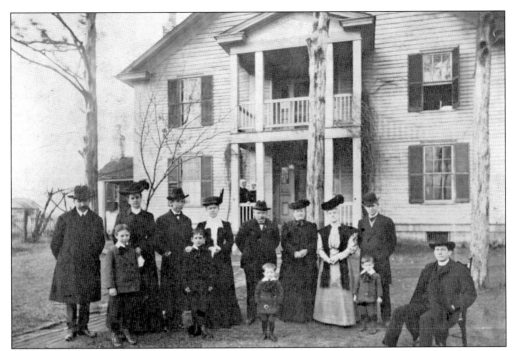

ORPHANAGE, 1905. On Tuesday, May 14, 1907, the Most Reverend Patrick J. Donahue, Bishop of Wheeling, dedicated St. Joseph's Orphanage for boys in Huntington, West Virginia. Pictured here are some of the boys who were under the care of the dedicated sisters at the orphanage. Later, it was rededicated as St. Edward's College in 1909 and then became part of St. Mary's Hospital in 1924. (Courtesy of the Diocese of Wheeling-Charleston Archives.)

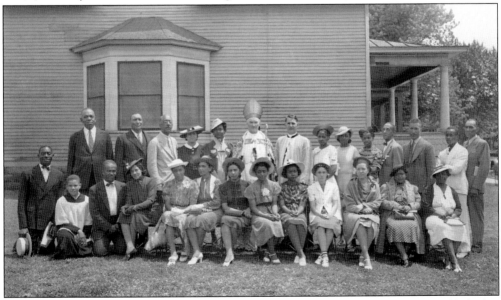

ST. PETER CLAVER PARISH, 1937. On February 7, 1937, St. Peter Claver Parish was established to serve the African American community of Huntington, West Virginia. Pictured in this photograph with Bishop John J. Swint are the first members of the parish, led by Rev. Leo Landoll, the first pastor of the parish. (Courtesy of the Diocese of Wheeling-Charleston Archives.)

PICNIC AT THE CHURCH, 1956. On a leisurely warm afternoon, some members of St. Coleman Parish in Irish Mountain enjoy a festive picnic. In the background are St. Coleman Parish and the parish's cemetery. (Courtesy of the Diocese of Wheeling-Charleston Archives.)

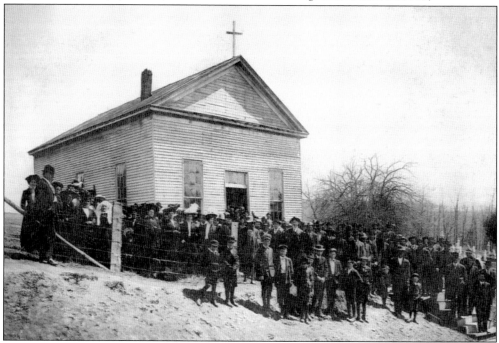

LAST MASS, 1908. The Catholic community of St. Bernard Parish in Loveberry celebrates the last mass in their old church. Within a few years, a new parish was built. (Courtesy of the Diocese of Wheeling-Charleston Archives.)

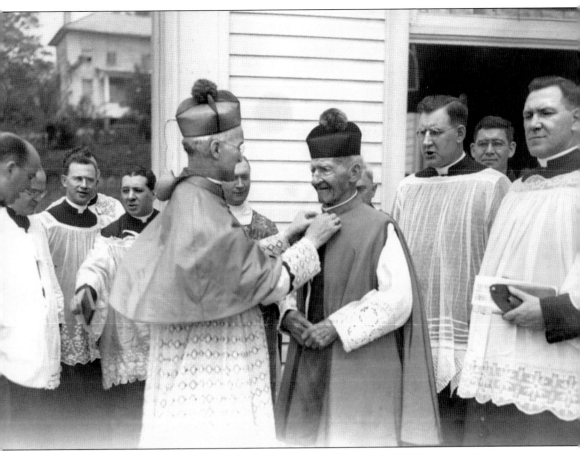

MSGR. THOMAS A. QUIRK, 1935. At the ripe old age of 90, Thomas A. Quirk became a monsignor. In this picture, along with Monsignor Quirk are Bishop John J. Swint and other members of the clergy. (Courtesy of the Diocese of Wheeling Charleston Archives.)

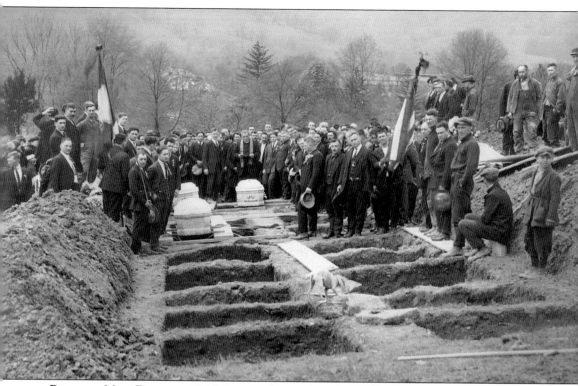

BENWOOD MINE DISASTER, 1924. Stories of triumph and tragedy are equally part of the diocese's heritage. For the community of Benwood, the Benwood Mine Disaster was a tragedy that changed the region forever. On Monday, April 28, 1924, at a few minutes past 7:00 a.m., gas and coal dust ignited, and the mine exploded and killed 119 men. The priests from the area converged, including Msgr. Fredrick J. Schwertz. Most of the men killed were Catholic and were buried at Mount Calvary. The scene here took place on Monday, May 5, 1924, at 2:30 p.m., when 22 miners were interred in the largest mass funeral the city had ever witnessed. Three languages were used at the service. The priests attending were Fathers Moye, Weber, Shoenen, Schwertz, Corcoran (Italian language), and Musical (Polish language). Fr. P. M. Shoenen of Benwood is shown reading prayers, and to his left is Peter Altmeyer, sexton of the cemetery. The names of those buried included Vetello, Mariano, Robinski, Corbi, Moleski, and Parise. (Courtesy of the Diocese of Wheeling-Charleston Archives.)

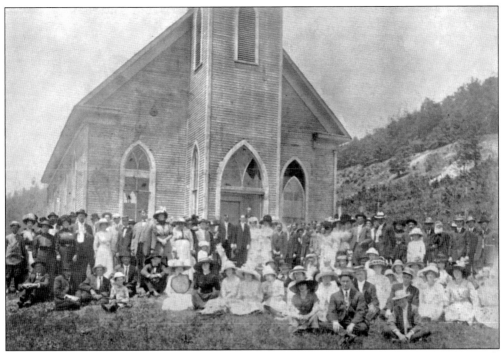

A NEW PARISH, 1915. Pictured in front of their new church are parishioners of St. Michael Parish in Braxton County. (Courtesy of the Diocese of Wheeling-Charleston Archives.)

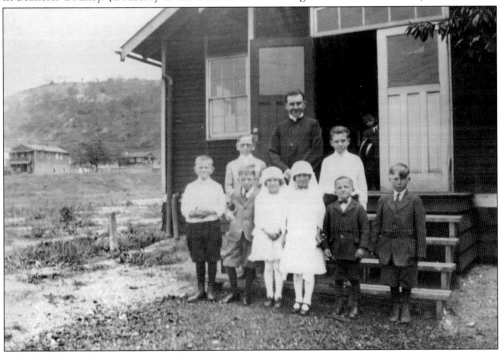

FIRST COMMUNION, 1925. Standing with Msgr. Fredrick J. Schwertz in front of Holy Family Church in Power, these children had just received their first Holy Communion. (Courtesy of the Diocese of Wheeling-Charleston Archives.)

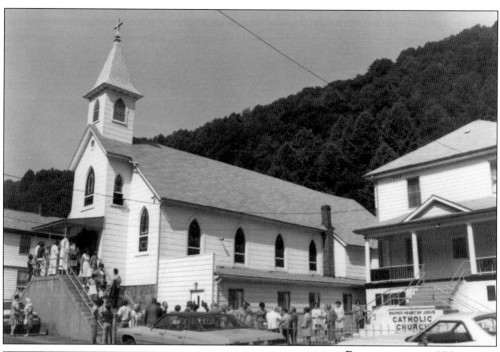

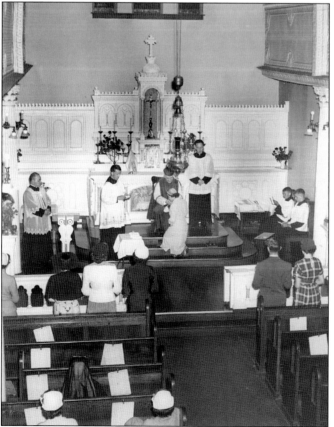

REDEDICATION, 1978.
On June 25, 1978, the Catholic community of Powhatan celebrates the rededication of Sacred Heart Parish. (Courtesy of the Diocese of Wheeling-Charleston Archives.)

THE FIRST LAY CATECHIST GRADUATE, 1951. On June 17, 1951, eighteen members of the first Lay Catechist graduate from St. Catherine's Church in Ronceverte, West Virginia. Overseeing this ceremony were, from left to right, Rev. Lawrence Becker, pastor of St. Patrick's Parish in Hinton; Rev. Edward Belanger, pastor of St. Catherine's Parish in Ronceverte, West Virginia; Coadjutor Bishop Thomas J. McDonnell; and Rev. Daniel M. Kirwin, superintendent of schools. (Courtesy of the Diocese of Wheeling-Charleston Archives.)

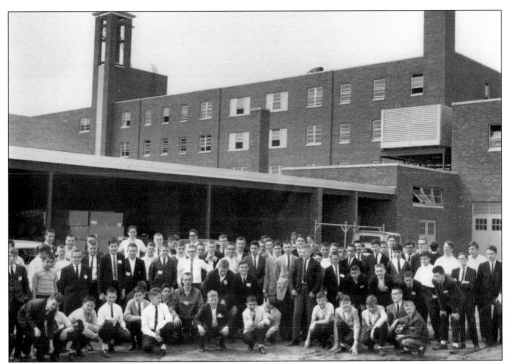

WHEELING YOUTH VISIT, 1964. Catholic students in Wheeling make their annual visit to tour St. Joseph Preparatory Seminary. (Courtesy of Charles F. Gruber Studios.)

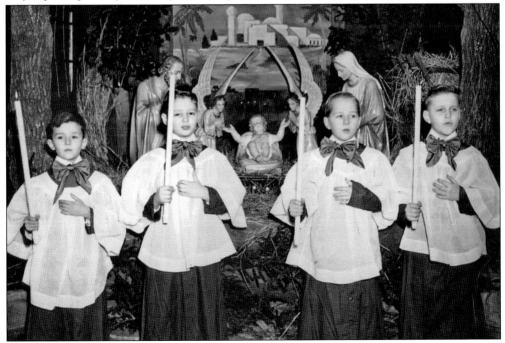

ALTAR BOYS, 1949. Along with the priests, altar boys have always played an important role in the mass. In this 1949 Christmas photograph, altar boys from St. Ladislaus Parish are standing in front of the Parish's manger scene. (Courtesy of the Diocese of Wheeling-Charleston Archives.)

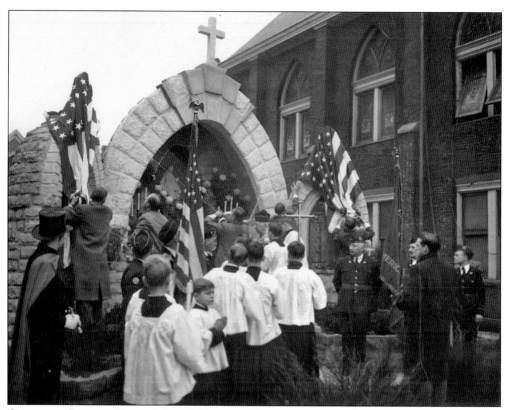

GROTTO OF BLESSED VIRGIN MARY MOTHER OF GRACE, C. 1949. The grotto, made and built by 43 service men of St. Ladislaus Parish, was dedicated in 1949 as a memorial to the living and the dead of World War II. (Courtesy of the Diocese of Wheeling-Charleston Archives.)

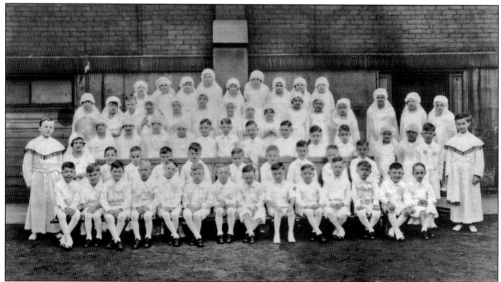

FIRST COMMUNION, 1934. Dressed in shiny white gowns and bonnets, the young children of St. Mary Parish are receiving their First Holy Communion. (Courtesy of the Diocese of Wheeling-Charleston Archives.)

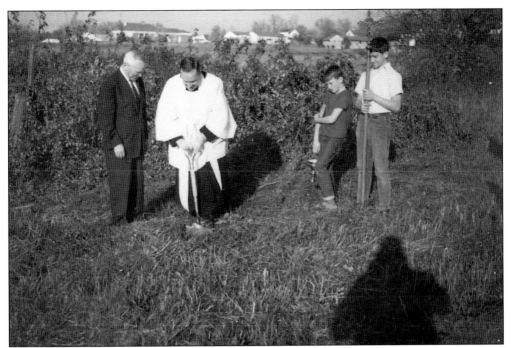

GROUND-BREAKING OF THE NEW ST. MARY PARISH, C. 1967. In this picture, Fr. Robert C. Nash, pastor of the parish, is present in Star City to break ground with the ceremonial shovel. Two years later, the new church was completed. (Courtesy of the Diocese of Wheeling-Charleston Archives.)

FIRST MASS, 1958. Gathered in front of St. Thomas Parish in Thomas are the first parishioners to celebrate mass, held by Fr. Alvin Manni. (Courtesy of the Diocese of Wheeling-Charleston Archives.)

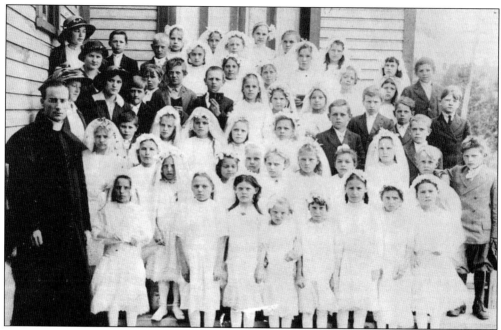

FIRST HOLY COMMUNION, 1915. Children stand at the entrance of St. Thomas Parish for a group photograph on the day they received their First Holy Communion. Along with the children is Fr. Thomas Duffy (on the left), pastor of St. Thomas. (Courtesy of the Diocese of Wheeling-Charleston Archives.)

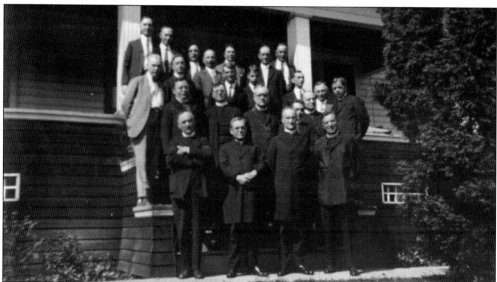

DEDICATION OF A NEW CHURCH, 1925. The cornerstone of the new parish was laid on June 22, 1924, with Bishop John J. Swint officiating and Rev. Fredrick Schwertz as master of ceremonies. Little more than a year later, on July 19, 1925, the new church was dedicated in honor of Our Lady of Seven Dolors. This picture, taken during the dedication of the parish, includes all the priests and community members who were involved in the day's ceremonies. In front of the group is Bishop John J. Swint, and Monsignor Schwertz is to his right. (Courtesy of the Diocese of Wheeling-Charleston Archives.)

ECUMENICAL SCRIPTURE WORKSHOP, 1983. Christian denominations from Lutheran, Baptist, Episcopal, Methodist, and Presbyterian faiths attended the 13th Annual Ecumenical Scripture Workshop at St. Joseph Preparatory Seminary in Vienna, West Virginia. (Courtesy of Charles F. Gruber Studios.)

MASS, C. 1950. Rev. James P. Altmeyer celebrates mass with parishioners of St. Joseph the Worker Parish in Weirton. (Courtesy of the Diocese of Wheeling-Charleston Archives.)

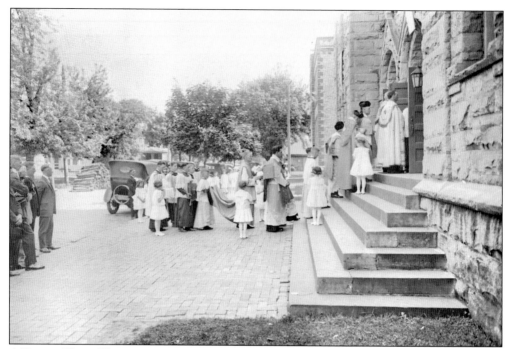

A BISHOP VISITS HOME, C. 1925. A native of Weston, Bishop John J. Swint celebrates mass at St. Patrick's Parish. It was with this parish community that Bishop Swint made known his desire to enter the seminary. (Courtesy of the Diocese of Wheeling-Charleston Archives.)

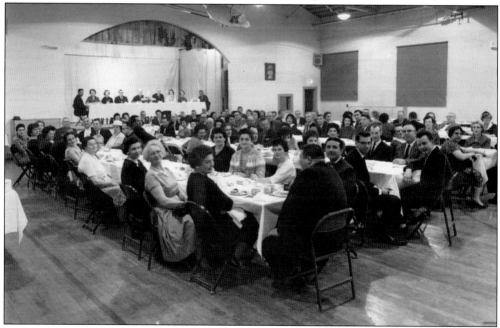

ST. PATRICK'S DAY DINNER, C. 1960. Members of the Confraternity of Christian Doctrine (CCD) program of Sacred Heart Parish in Wheeling put on a St. Patrick's Day Dinner in the school's gymnasium. The CCD is a religious education program of the Catholic Church, normally designed for children. (Courtesy of the Diocese of Wheeling-Charleston Archives.)

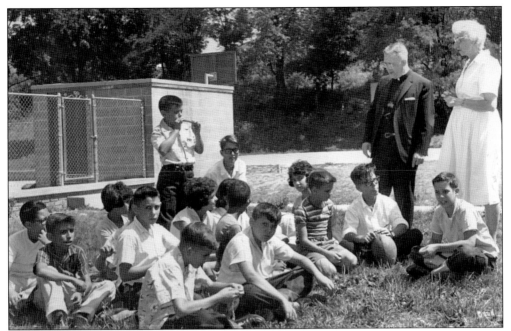

ST. JOHN'S HOME FOR BOYS, C. 1971–1972. Some of the children from St. John's Home for Boys sit out on the grass on a nice, sunny day. Within a few years, St. John's Home and St. Vincent's Home for Girls were merged and renamed St. John's Home for Children. (Courtesy of the Diocese of Wheeling-Charleston Archives.)

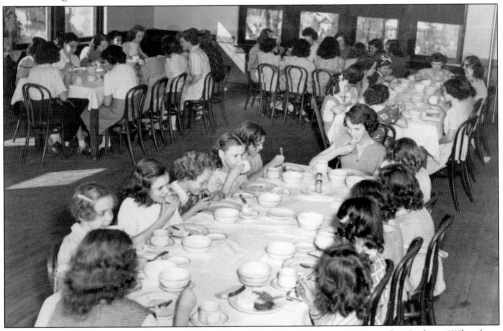

ST. VINCENT'S HOME FOR GIRLS, 1930s. The girls of St. Vincent's Home for Girls in Wheeling gather in the dining room for supper in the St. Thomas More Center. The St. Thomas Moore Center was adjacent to St. Vincent de Paul Parish in Elm Grove. (Courtesy of the Diocese of Wheeling-Charleston Archives.)

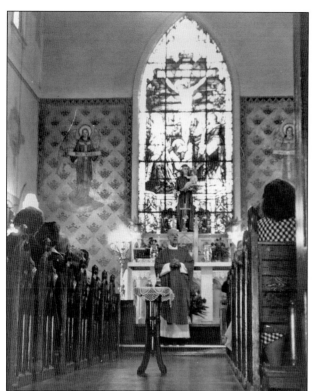

THE LAST MASS, 1978. On October 22, 1978, parishioners of St. Anthony's Chapel celebrated the final mass, with Rev. John T. Mueller as the celebrant. Concelebrating the final mass were Msgr. F. Edmund Yahn, Father Bell, Monsignor Farrell, and Fr. Joseph DeBias. The chapel, along with several other buildings, was demolished to make way for Interstate 470. (Courtesy of the Diocese of Wheeling-Charleston Archives.)

MISSION CRUSADE, 1924. On the property of Mount de Chantal Visitation Academy, students, clergy members, and the Catholic community gather for the Catholic Student Mission Crusade of 1924. (Courtesy of the Mount de Chantal Visitation Academy Archives.)

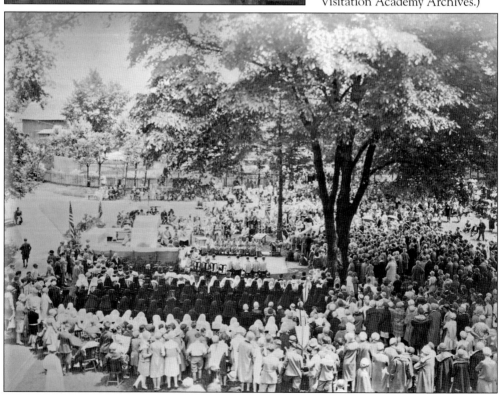

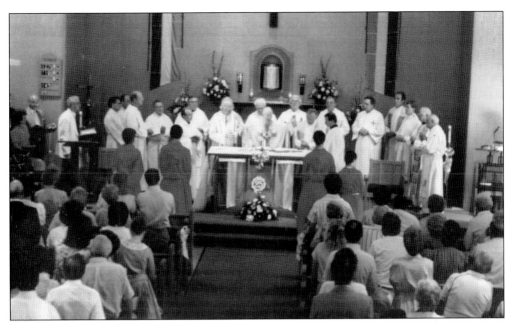

THE 25TH ANNIVERSARY, 1987. Parishioners of Our Lady of Peace celebrate the 25th anniversary of their parish with Bishop Francis B. Schulte. Concelebrants of the mass are, behind the altar from left to right, Fathers Raymond Jablinske, pastor; Robert Lee from the Diocese of Galway, Ireland, who was pastor from 1962 to 1974; and Carl Bauer, pastor of St. Mary Parish in Star City, who served as pastor from 1974 to 1985. (Courtesy of Dorsey Photo.)

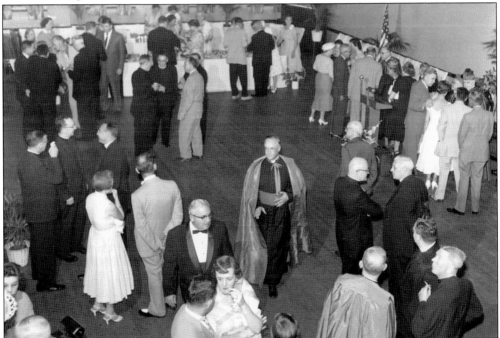

MSGR. FREDRICK SCHWERTZ, 1957. A reception was held at the Catholic Women's League Gym for Msgr. Fredrick Schwertz in honor of his 35th year as a priest. (Courtesy of Charles F. Gruber Studios.)

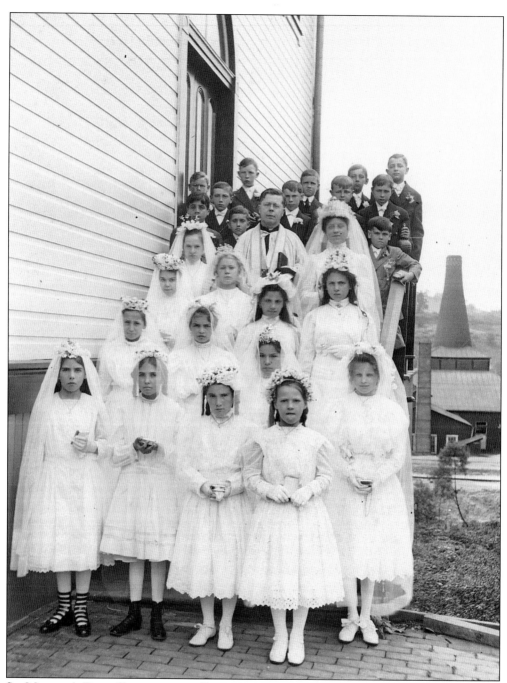

St. Michael's First Communion, c. Late 1897–1900. Rev. C. J. Kluser, the first pastor of St. Michael's Parish in Wheeling, is with first Holy Communicates on the steps of St. Michael's. The first St. Michael's Parish, located at 127 Edgington Lane, was dedicated on July 4, 1897. Bishop Patrick J. Donahue and Rev. C. J. Kluser celebrated the first mass. Reverend Kluser remained pastor of St. Michael's until 1900. Due to the population, a new St. Michael Parish was constructed at its current location, 1225 National Road. The Most Reverend John J. Swint, Bishop of Wheeling, dedicated it on Sunday, March 23, 1952. (Courtesy of the Diocese of Wheeling-Charleston Archives.)

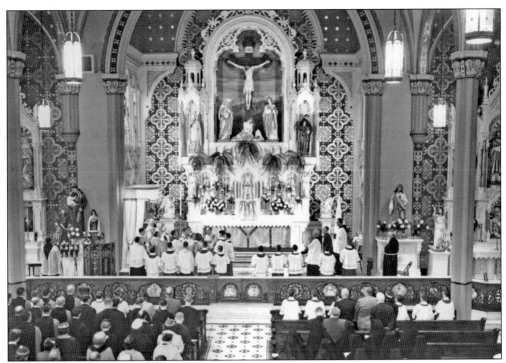

CENTENARY MASS, 1956. The proud German community of St. Alphonsus Parish in Wheeling comes to rejoice at its 100th-Anniversary Mass. Celebrating the mass are Archbishop Swint (standing on the far left) and Rev. Philip Freeland, Order of Friars Minor Capuchin (O.F.M.Cap.) (reading from the liturgy), pastor of St. Alphonsus. (Courtesy of Charles F. Gruber Studios.)

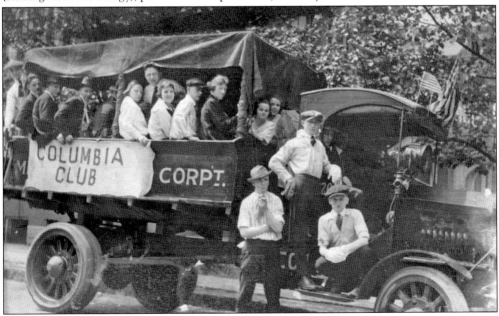

FOURTH OF JULY PARADE, 1910s. Members of the Columbia Dramatic and Musical Club are participating in the annual Wheeling Fourth of July Parade. (Courtesy of the Diocese of Wheeling-Charleston Archives.)

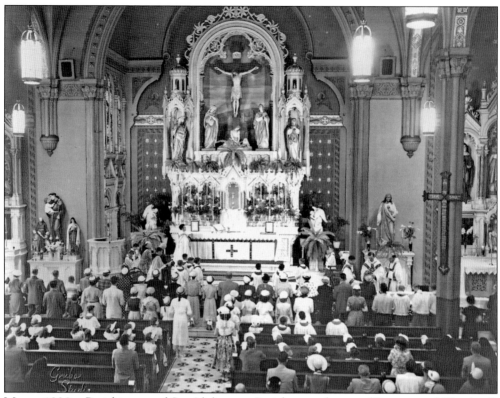

Mass, 1930s. Parishioners of St. Alphonsus Parish attend mass. (Courtesy of Charles F. Gruber Studios.)

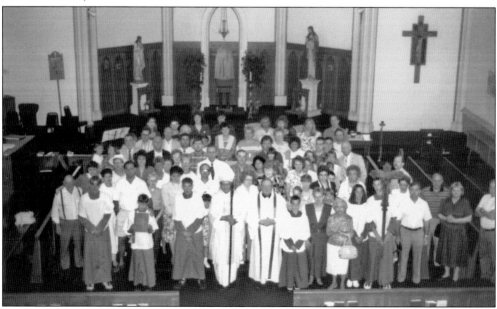

Last Mass at St. Mary's, 1995. After 122 years of service, the community of St. Mary Parish celebrated its last mass with Bishop Bernard Schmitt (middle) and Patrick A. Condron (pictured to the bishop's right), pastor. (Courtesy of Charles F. Gruber Studios.)

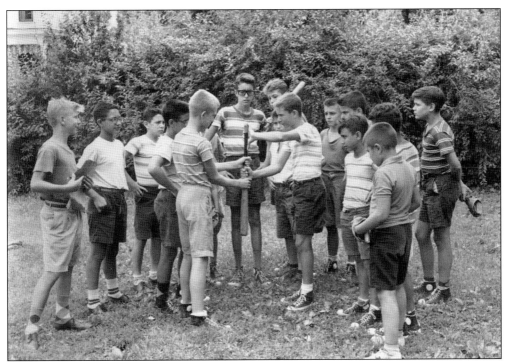

LET'S PLAY BALL, 1963. The boys of St. John's Home for Boys gather round the baseball bat to decide which team each will play on. (Courtesy of Charles F. Gruber Studios.)

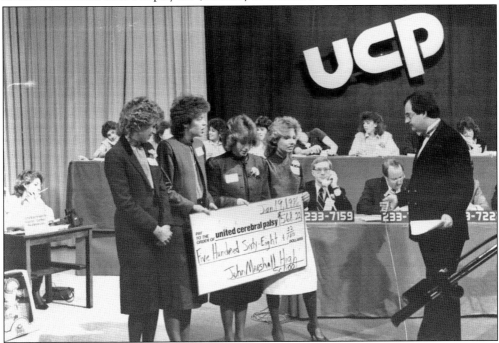

UPC TELETHON, 1986. On January 19, 1986, students from John Marshall High School present a check for $568.22 to Joe Wolfe of WTOV-TV 9 for the United Cerebral Palsy Telethon, which was held at the Diocesan Communications Center in Wheeling. (Courtesy of Levitt Photo.)

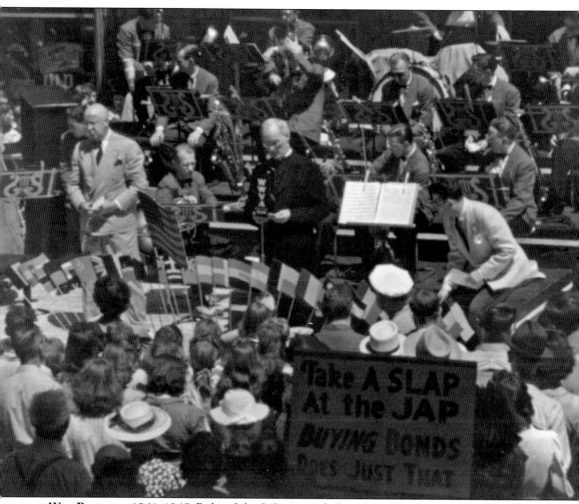

WAR BONDS, C. 1941–1945. Bishop John J. Swint made frequent public appearances throughout West Virginia during World War II. Bishop Swint is photographed speaking at a war bond rally in Wheeling. (Courtesy of Charles F. Gruber Studios.)

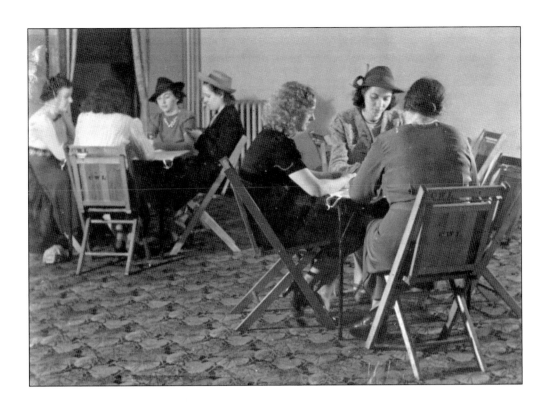

CATHOLIC WOMEN'S LEAGUE, 1940S. The Catholic Women's League, headquartered at 1401 Chapline Street, was organized in Wheeling on May 18, 1913, and become a state-recognized corporation on April 20, 1920. The league promoted the spiritual, intellectual, social, and physical development of women within a homelike atmosphere. The education program offered girls classes on dramatics, knitting, sewing, better speech, home economics, current events, and various types of dance. (Both, courtesy of the Diocese of Wheeling-Charleston Archives.)

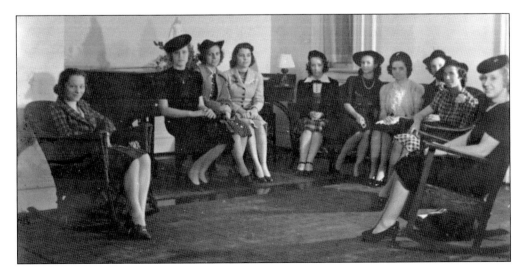

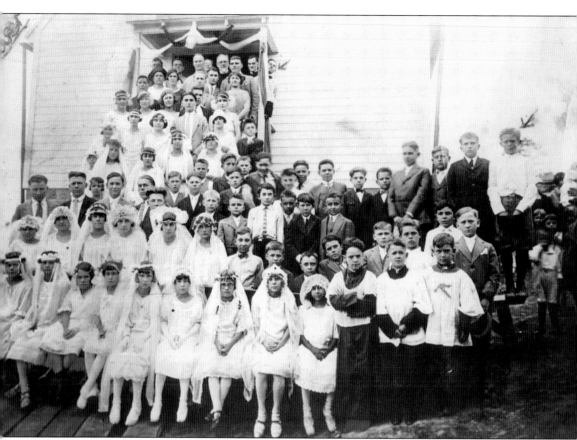

CONFIRMATION, C. 1925. In this picture is the first confirmation class of St. Theresa Mission in Windsor Heights. At the top of the staircase is Bishop John J Swint, who ministered the confirmation. (Courtesy of the Diocese of Wheeling-Charleston Archives.)

Four

CATHOLIC SCHOOL EXPERIENCE

While the students' surroundings may have changed, the Catholic school experience has remained the same through the education of the heart, mind, and spirit of the student. What distinguishes Catholic education from others is the interweaving of faith with academics. Essentially, Catholic education is the building block for the continuity of the church. The spiritual and intellectual strength of each generation of students is a direct result of the sisters, priests, teachers, and families of these young people, who will go on to take their elders' places. Catholic school is not just about academics and direct religious teaching. There is also camaraderie between students through sports, clubs, retreats, and other extracurricular activities. The photographs in this chapter illuminate the experiences of the church's valuable youth.

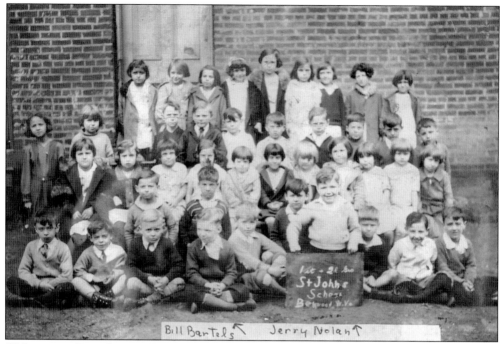

SS James and John School, Benwood, c. 1935. In this class picture are the first- and second-grade classes of SS James and John School in Benwood. The date for this photograph is unknown. The child holding the sign is Jerry Nolan. (Courtesy of the Diocese of Wheeling-Charleston Archives.)

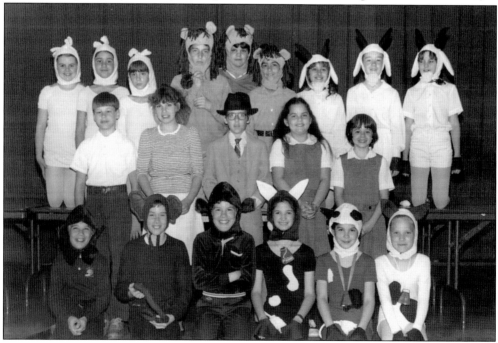

Spring Musical, 1983. Students of St. Michael Parish in Wheeling held their spring musical, entitled "The Wackadoo Zoo," on May 17, 1983, in conjunction with the Parent-Teacher Organization meeting. (Courtesy of Charles F. Gruber Studios.)

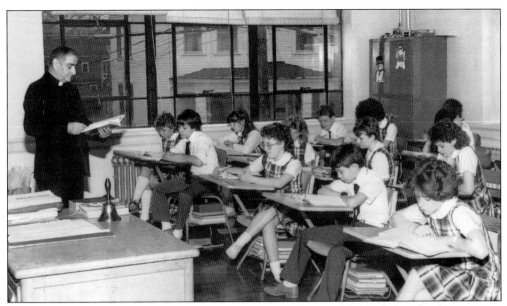

SCHOOL UNIFORMS, 1987. The uniform has always been a fixture of the Catholic school experience. In both of these photographs, the students of Blessed Trinity School in Wheeling are busy at work in the classroom, while their teachers lead them in their lesson. The Sisters of St. Joseph's school program started in 1931 with the first grade through the eighth grade. By the time of this photograph, the sisters were still involved in teaching the students. The priest above is Rev. Eugene Jacobs. (Both, courtesy of the Diocese of Wheeling-Charleston Archives.)

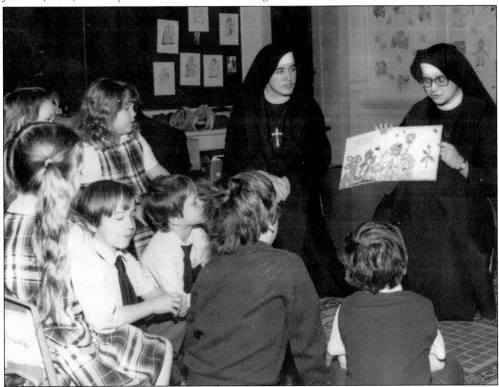

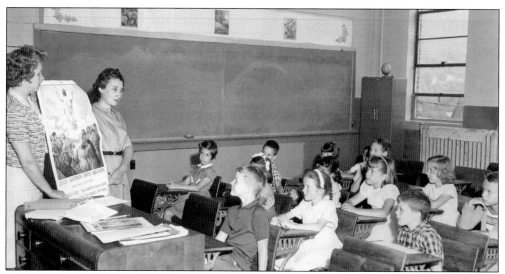

RELIGIOUS VOCATION SCHOOL, 1962. The second-grade students of Sacred Heart Religious Vocation School in Bluefield pay close attention, as their teachers, Mrs. William Seyler (left) and Mrs. Maurice Bowling (right), show them a teaching aid on Jesus's Ascension to Heaven. (Courtesy of the *West Virginia Catholic Register.*)

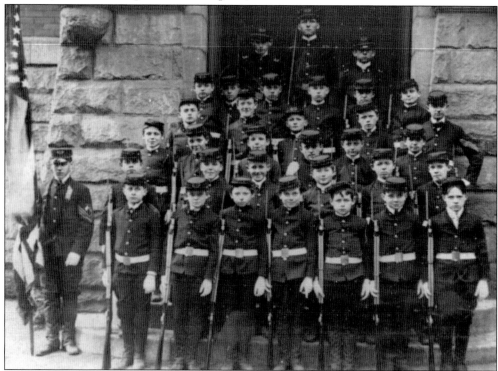

CATHEDRAL PARISH SCHOOL, COMPANY B, 1903. The original school was established in September 1858 and was staffed by the Visitation Sisters, local priests, and seminarians. In the picture above is Capt. Joseph J. Wagner (sixth row, middle); 1st Lt. Bernard Madden; 2nd Lt. Charles Goldbaugh; and William Stenger, Color Guard (far left with flag). (Courtesy of the Diocese of Wheeling-Charleston Archives.)

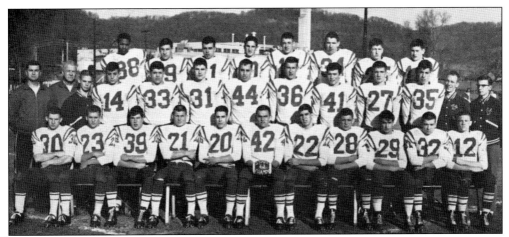

CATHOLIC STATE CHAMPIONS, 1962. The 1962 football season was one to remember. Sportswriters acclaimed the team as "A Football Team Called DESIRE." Charleston Catholic High School was the first unbeaten and untied football team that the city of Charleston had since 1947. It was a team that operated on quite a bit of talent and a great deal of courage. This squad of "Fighting Irish" went on to capture the first West Virginia Catholic Football Championship on November 16, 1962, in Parkersburg. Lead by coach Mickey McDade, Charleston Catholic played Wheeling Central, winning the game by a score of 13-7. (Courtesy of the Diocese of Wheeling-Charleston Archives.)

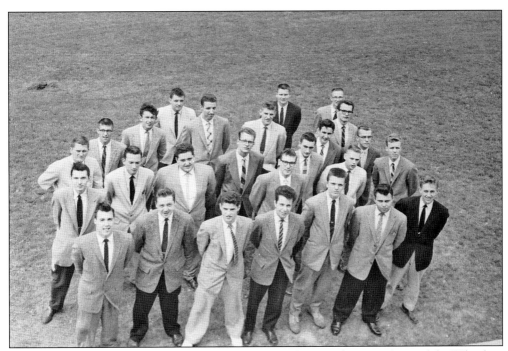

WHEELING COLLEGE STUDENTS, 1950s. In this group photograph are students of the Wheeling College Engineering Department. (Courtesy of the *West Virginia Catholic Register.*)

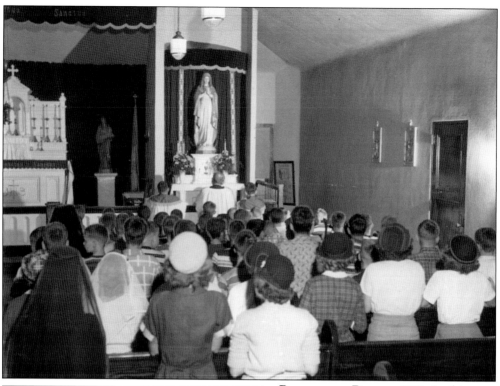

PRAYING THE ROSARY, 1951. In this October 1951 photograph, St. Agnes School children are reciting the Holy Rosary at St. Agnes Parish in Charleston. (Courtesy of the Diocese of Wheeling-Charleston Archives.)

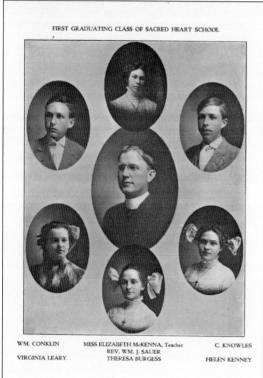

FIRST GRADUATING CLASS OF SACRED HEART SCHOOL

WM. CONKLIN MISS ELIZABETH McKENNA, Teacher C. KNOWLES
REV. WM. J. SAUER
VIRGINIA LEARY THERESA BURGESS HELEN KENNEY

FIRST CLASS, 1904. This class picture is of Sacred Heart School's first class. Teacher Elisabeth McKenna and Fr. William J. Sauer, pastor of Sacred Heart Parish in Chester, are pictured with the students. (Courtesy of the Diocese of Wheeling-Charleston Archives.)

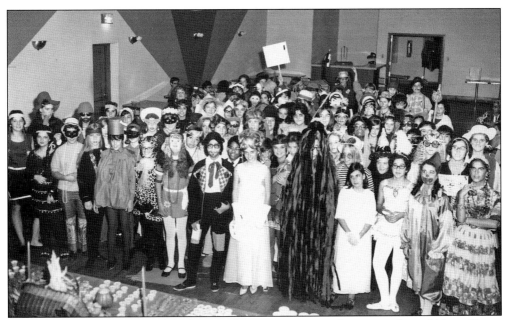

HALLOWEEN, 1960S. Dressed in their Halloween costumes, the junior class of Notre Dame High School in Clarksburg is partaking in the Halloween festivities. (Courtesy of the Diocese of Wheeling-Charleston Archives.)

SUMMER SCHOOL, 1958. For the kids of St. Patrick's School in Coalton, the school year never ended. Pictured with summer school students are Sisters Thomas (left) and Campbell (right). (Courtesy of the Diocese of Wheeling-Charleston Archives.)

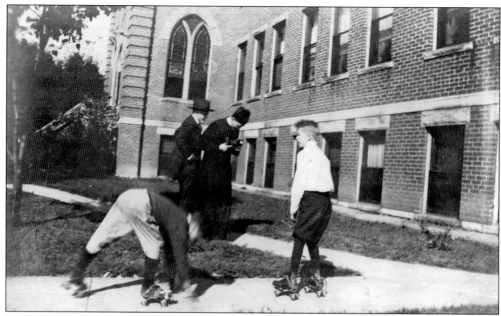

ST. EDWARD'S COLLEGE, 1922. Opened on September 9, 1909, St. Edward's College, a Catholic school for young men, was one of the few private schools located in Huntington. In the 1920s, St. Edward's relinquished its school and property to the Pallottine Sisters, and the property became St. Mary's Hospital. Taken during the spring of 1922, this photograph shows kids on roller skates and Fr. Francis P. Scheuermann in the background, holding his camera. (Courtesy of the Diocese of Wheeling-Charleston Archives.)

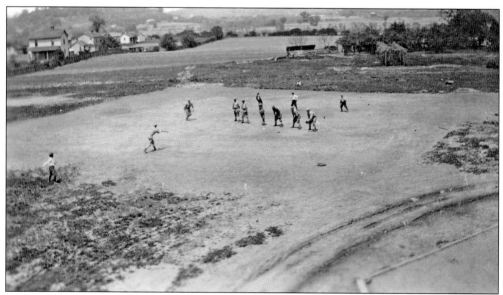

ATHLETIC FIELD, 1922. At St. Edward's College, playing sports was an important activity for the students. In this photograph, the kids are playing baseball. (Courtesy of the Diocese of Wheeling-Charleston Archives.)

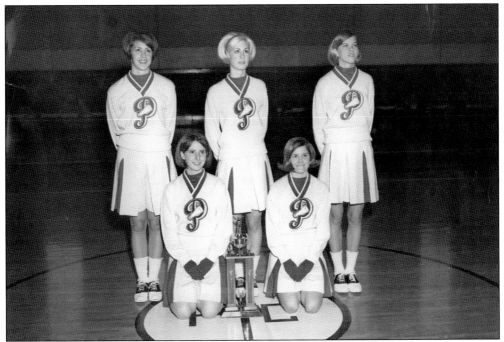

CHEER CAMP, 1969. In this photograph are members of the Parkersburg Catholic High School cheerleading squad. At cheer camp, the squad received medals and an award for their cheerleading skills and abilities. (Courtesy of the Diocese of Wheeling-Charleston Archives.)

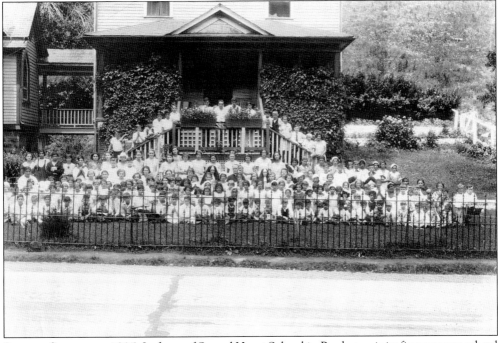

SUMMER SCHOOL, C. 1935. In front of Sacred Heart School in Powhatan is its first summer school class. Assistant pastor Fr. James A. McNulty and the sister who taught the students are pictured in the middle with the students. (Courtesy of the Diocese of Wheeling-Charleston Archives.)

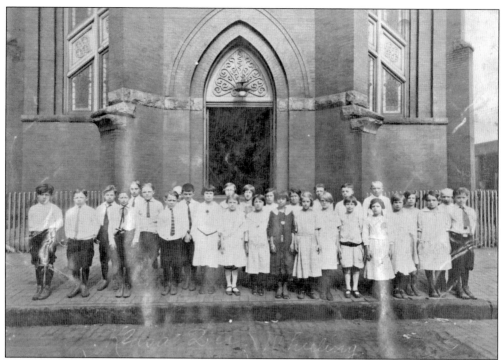

STUDENTS OF ST. LADISLAUS, C. 1910. Dressed in their uniforms and dress shoes are the students of St. Ladislaus School. (Courtesy of the Diocese of Wheeling-Charleston Archives.)

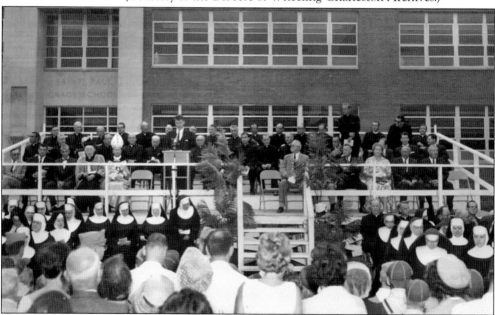

DEDICATION OF A NEW SCHOOL, 1963. On September 3, 1963, St. Paul's Parish in Weirton dedicated a new school and convent. Bishop Joseph H. Hodges (left of the podium); Msgr. William J. Lee, vicar general and spiritual director of the Dedication Committee (to the left of the bishop); other members of the Dedication Committee; and the community of St. Paul's Parish attended the dedication. (Courtesy of the Diocese of Wheeling-Charleston Archives.)

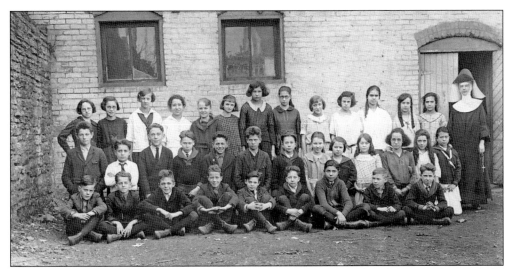

STUDENTS OF ST. JOHN SCHOOL, C. 1920. In the fall of 1917, St. John the Evangelist Catholic Grade School was established with the Sisters of Divine Providence as teachers. The order taught the students for two years, until the Franciscan Sisters of Charity of Manitowoc, Wisconsin, came to staff the school. Sister Modesta Bill is pictured with students. (Courtesy of the Diocese of Wheeling-Charleston Archives.)

ST. MARY'S BASEBALL TEAM, 1910S. On October 26, 1869, Sister Mary Charles and Sister Cecelia opened St. Mary's School in what was then known as Richie Town. In 1897, the present school building was erected. This photograph is of the school's baseball team. (Courtesy of the Diocese of Wheeling-Charleston Archives.)

Basketball Champions, 1990. This team photograph includes the coaches, staff members, and players of the Wheeling Central Catholic High School basketball team. In 1990, the team won the West Virginia State AA Championship and was named the Ohio Valley Athletic Conference Class AA champions. Their season record was 23-3. Pictured are, from left to right, the following: (first row) Sharon Hedinger (statistics), Mickey Duffy (athletic director), Brent Kaniecki, Dan Metz, Kevin Hendershot, Damion Saunders, Eric McGhee, Ken Fredericks, Mike Bishop, and Nate Robinson (manager); (second row) Holly Roth (stats), Joel Nau (assistant coach), Brian Janetski, Anthony Savage, Steve Riedel, Fernando Ibanez, Tom Burgoyne, Joe Donzella, Malachi Lee, J. R. Battista, Dan Angalich (assistant coach), and Jim Dailer (head coach). (Courtesy of the Diocese of Wheeling-Charleston Archives.)

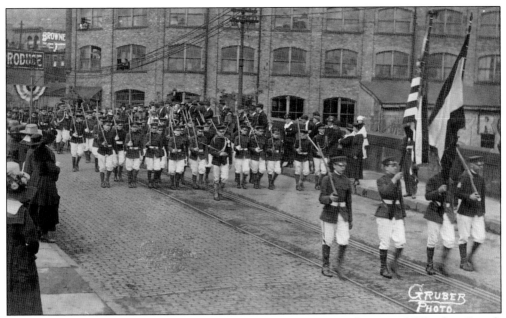

MARCHING BAND, C. 1917–1920. Marching down Main Street in the annual Wheeling Fourth of July parade are the members of the St. Joseph Cathedral School Fife and Drum Corps. (Both, courtesy of Charles F. Gruber Studios.)

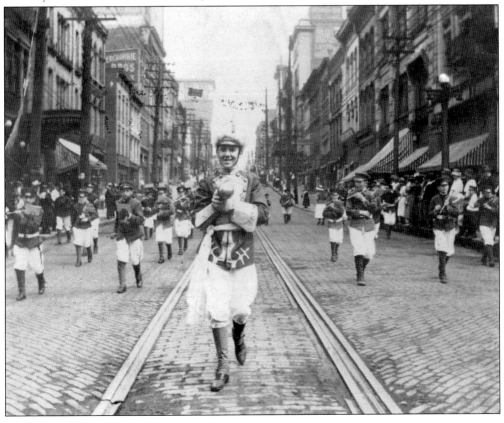

Students of Our Lady of Peace, 1963. Shown here on June 21, 1963, are students of Our Lady of Peace School with Bishop Joseph H. Hodges (in the middle); Fr. Robert E. Lee, pastor (on the top stair); and two of four Marist Sisters (on the far left and right). (Courtesy of Charles F. Gruber Studios.)

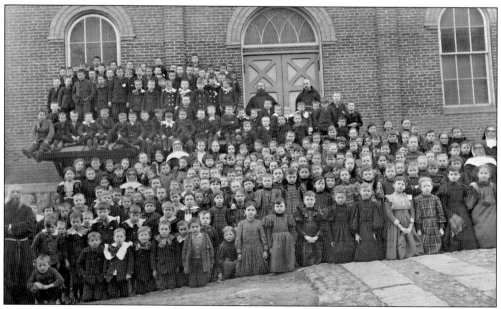

St. Alphonsus, Late 1890s. Dressed in their school uniforms and assembled in front of their school are the students of St. Alphonsus School. (Courtesy of the Diocese of Wheeling-Charleston Archives.)

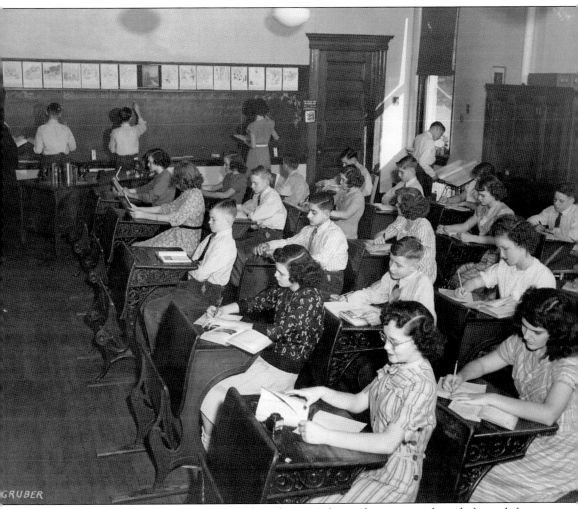

THE CLASSROOM, C. 1950. As their teacher observes, the students are at their desks and the chalkboard working diligently on the math lesson. The name of the school is unknown. (Courtesy of the Diocese of Wheeling-Charleston Archives.)

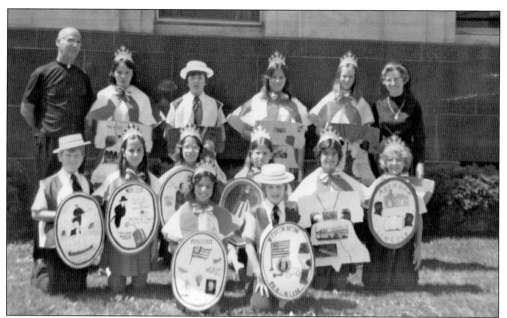

SACRED HEART PROGRAM, JUNE 27, 1976. Students of the Sacred Heart School in Williamson present a patriotic program on the stage in front of the Mingo County Courthouse in celebration of Young People's Day. Rev. Marcel Ballouz, pastor of Sacred Heart Parish, and Sister Mary Florence, principal of the school, are pictured with the students. (Courtesy of the Diocese of Wheeling-Charleston Archives.)

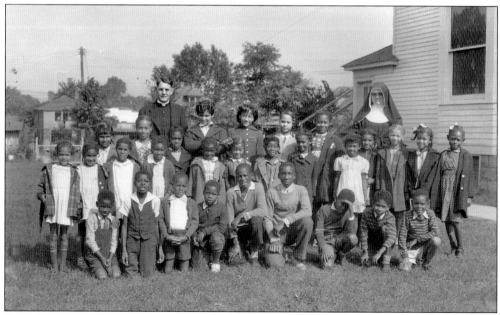

FIRST CLASS, 1939. Picture here are the first students of St. Peter Claver School in Huntington, West Virginia, in 1939. Along with the students are Rev. Leo Landoll, the first pastor of the parish, and Sister Mary Agnes. Under the leadership of Father Landoll and the Pallottine Missionary Sisters, two classrooms were established that served the first through the eighth grades. (Courtesy of the Diocese of Wheeling-Charleston Archives.)

Five

MOUNT DE CHANTAL
VISITATION ACADEMY

For over 150 years, the Mount de Chantal Visitation Academy had educated the hearts and minds of women throughout the diocese and around the world. The building itself is a marvel of beauty, with its stained-glass windows, chapel, and the many rooms dedicated to the arts. The Mount and its inhabitants have witnessed and played a role in some of the most trying moments in American history, the first being the Civil War, during which the sisters provided shelter and a good education for young ladies from war-ravaged towns. This school and Visitation Sisters have had a lasting impact on the Catholic communities in West Virginia and around the world. This place and its people have been a major component to the story of Catholics in West Virginia. While this brief chapter doesn't begin to tell the whole story of the Mount, it does provide a summary of images that reflect the spirit and the mission of the first set of Visitation Sisters who came to Wheeling over a century and a half ago.

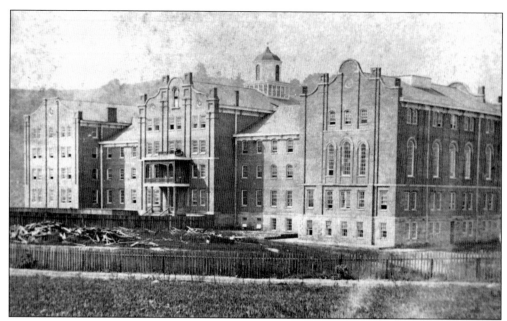

MOUNT DE CHANTAL, C. 1868. In 1865, the Visitation Sisters took up residence at their newly built school. This photograph shows that work on the Mount was still going on even after their move. (Courtesy of the Mount de Chantal Visitation Academy Archives.)

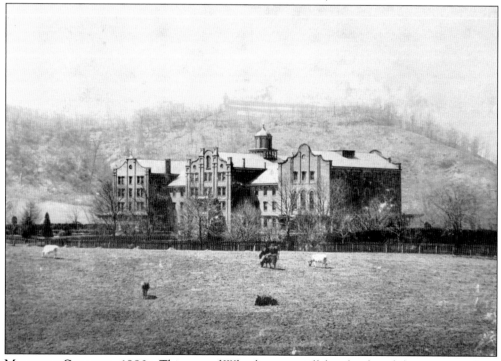

MOUNT DE CHANTAL, 1880S. This area of Wheeling was still farmland, and the property where the Mount was built was originally part of Steenrod Farm. In this photograph, cows can be seen grazing on the front lawn of the Mount. (Courtesy of the Mount de Chantal Visitation Academy Archives.)

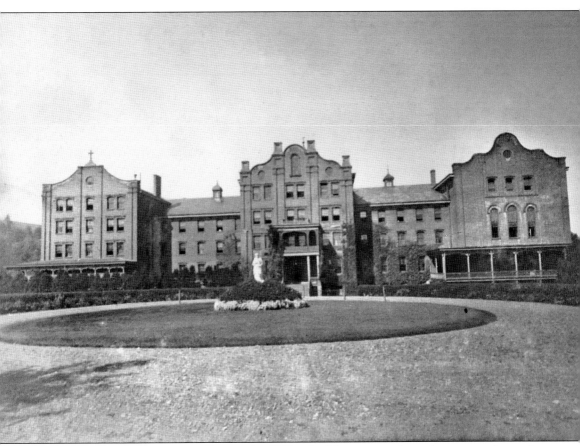

Mount de Chantal, c. 1910. During the 1900s, the Mount went through an expansion and renovation period. In this photograph, the front porches, the stained-glass windows in the Music Hall (on the building's right), and the French window in the study hall/library (on the building's right) can be seen. (Courtesy of the Mount de Chantal Visitation Academy Archives.)

AERIAL VIEW, 1900s. The aerial view of the Mount shows the new east and west wings of the building, which included an art studio, music hall, and a gymnasium. In the background are the growing neighborhoods of Woodsdale, Elmwood, and Pleasant Valley. (Courtesy of the Mount de Chantal Visitation Academy Archives.)

THE BARN, 1889. On the grounds of the Mount de Chantal Visitation Academy were a number of animals, a barn, several gardens, and the Sister's Cemetery. The Mount was a self-sufficient institution for the girls and sisters who lived and worked there. (Courtesy of the Mount de Chantal Visitation Academy Archives.)

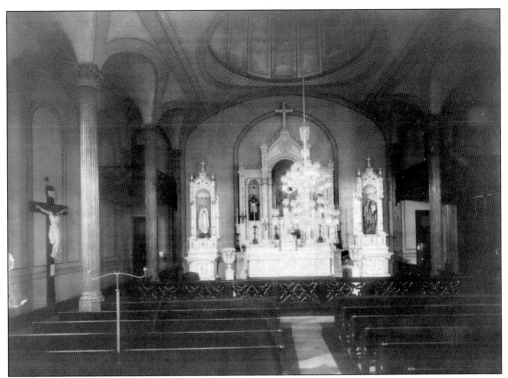

THE CHAPEL, 1888. The stained-glass windows, large pipe organ, and the details of the altar illustrate the beauty of this chapel. This sacred place was the focal point of the Mount de Chantal community and was where mass and other ceremonies were held. Throughout its history, bishops, cardinals, politicians, dignitaries, and members of the Wheeling community celebrated mass in this chapel. (Courtesy of the Mount de Chantal Visitation Academy Archives.)

THE SISTER'S CEMETERY, 1892. This is the final resting place for many of the Visitation Sisters who worked and lived at Mount de Chantal. (Courtesy of the Mount de Chantal Visitation Academy Archives.)

THE MUSIC HALL, 1909. Located on the second floor of the Mount is the Great Music Hall, where students gave music recitals and performances in front of their friends and family. Many of the pianos seen in the photograph are still there. (Courtesy of the Mount de Chantal Visitation Academy Archives.)

THE ART STUDIO, C. 1900. The Mount de Chantal Visitation Academy prided itself in the study of music and art. Located in the new wing of the building, the art studio was used by many students who worked tirelessly on the art seen in this photograph. (Courtesy of the Mount de Chantal Visitation Academy Archives.)

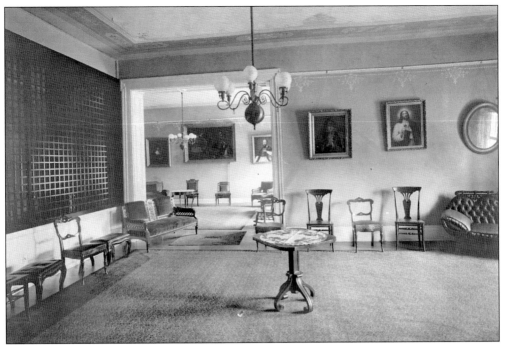

THE PARLOR, C. 1913. The parlor, located off the front entrance, was one of the first rooms seen by students and visitors as they entered the Mount. (Courtesy of the Mount de Chantal Visitation Academy Archives.)

THE GYM, C. 1913. Just like today, fitness and health were parts of any good school's curriculum. At the Mount, the students used the gymnasium for their daily fitness and exercise routines. (Courtesy of the Mount de Chantal Visitation Academy Archives.)

THE MUSIC PRACTICE HALL, C. 1913. On the second floor of the new wing of the Mount was a row of music practice rooms, like the one seen in this photograph. Students, along with music teachers, would practice and learn to craft great musical works there. (Courtesy of the Mount de Chantal Visitation Academy Archives.)

THE PLAYROOM, C. 1913. Located between the dormitory and school was the playroom, which was a popular hangout spot for the students of the Mount. (Courtesy of the Mount de Chantal Visitation Academy Archives.)

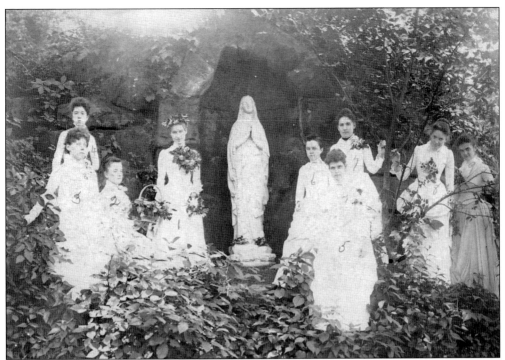

MAY QUEEN, 1889. On the north side of the Mount is the Grotto. Pictured are members of the May Queen court. To the left of the statue of St. Mary is Margaret McKenna, the May Queen, holding flowers. (Courtesy of the Mount de Chantal Visitation Academy Archives.)

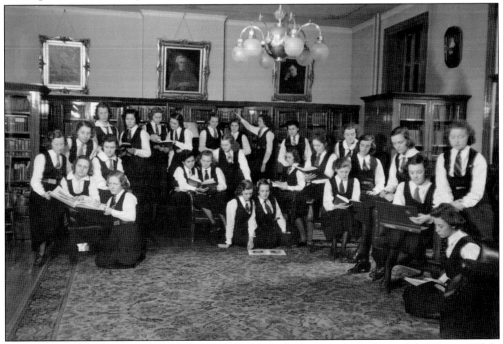

LITERARY CLUB, C. 1937–1938. Meeting in the Mount's library are members of the Literary Club. (Courtesy of the Mount de Chantal Visitation Academy Archives.)

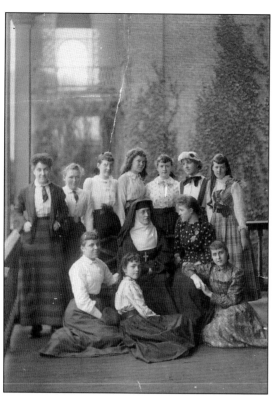

SISTER XAVIER SLATER, C. 1892.
Students on the front of the Mount
surround Sister Xavier Slater, a
Visitation nun. (Courtesy of the
Mount de Chantal Visitation
Academy Archives.)

STUDENTS OF THE MOUNT, C. 1920.
Wearing their traditional uniforms
of white blouses and black skirts are
some of the students of the Mount.
(Courtesy of the Mount de Chantal
Visitation Academy Archives.)

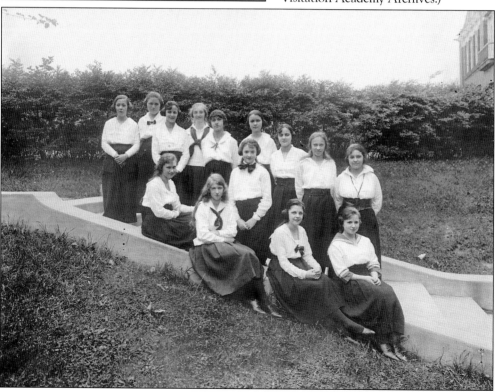

THE SISTERS, C. 1900. Dressed in the traditional habits are, from left to right, Sisters Mary Francis Gannon, Marguerite, and Antonia with Dora Scott (front). (Courtesy of the Mount de Chantal Visitation Academy Archives.)

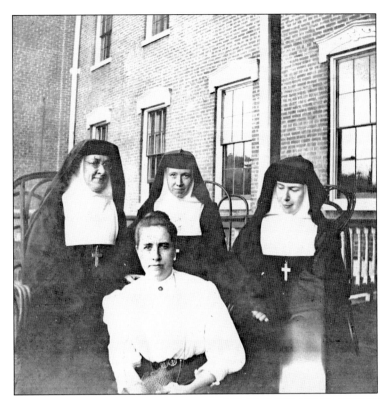

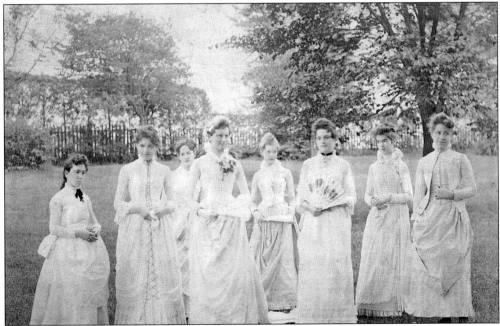

GRADUATION, C. 1885–1889. For the students of the Mount, graduation was the completion of many years of hard work and the beginning of something new. This special day was filled with social gatherings with friends, families, teachers, and other classmates. (Courtesy of the Mount de Chantal Visitation Academy Archives.)

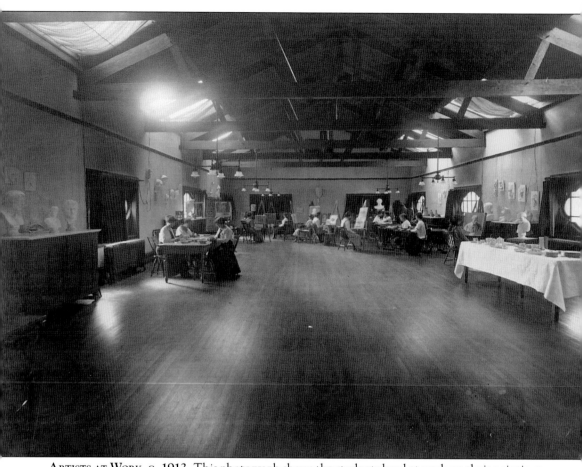

ARTISTS AT WORK, C. 1913. This photograph shows the students hard at work on their paintings and other pieces of art. Until Mount de Chantal closed in 2008, Georgette Stock continued this fine tradition of art education. (Courtesy of the Mount de Chantal Visitation Academy Archives.)

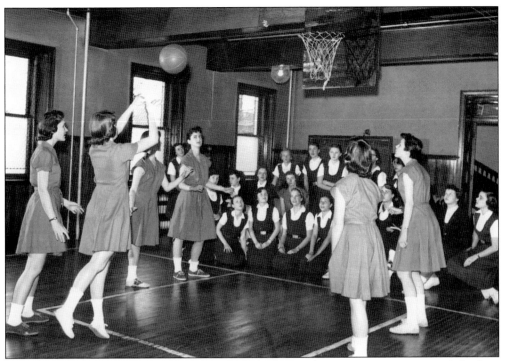

BASKETBALL, C. 1950. The girls in this photograph are playing an intense game while their fellow classmates watch on the sidelines. (Courtesy of the Mount de Chantal Visitation Academy Archives.)

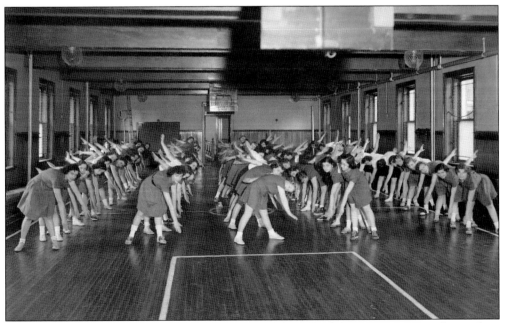

GYM CLASS, C. 1950. Dressed in their gym clothes, the girls of the Mount are completing their exercises. (Courtesy of the Mount de Chantal Visitation Academy Archives.)

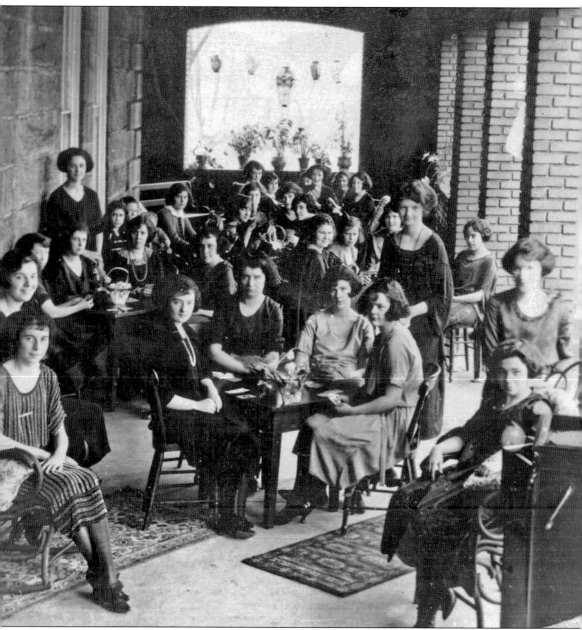

TEA PARTY, C. 1922. Student gather outside on the porch for a pleasant tea party. (Courtesy of the Mount de Chantal Visitation Academy Archives.)

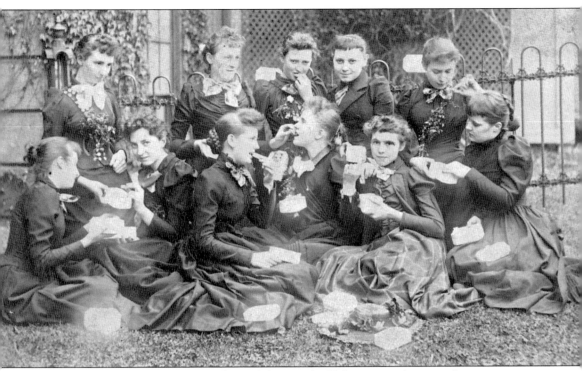

THE CANDY CLUB, C. 1891. Members of the Candy Club enjoy a pleasant afternoon eating delicious treats. In recent years, candy made by the sisters was sold at the annual turkey dinner. (Courtesy of the Mount de Chantal Visitation Academy Archives.)

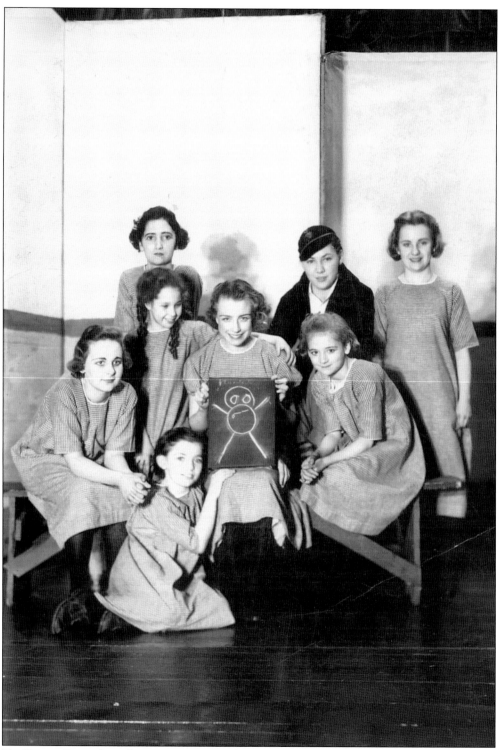

THE PLAY OF DADDY LONG LEGS, C. 1935. Pictured on stage are actresses from the student-run production of *Daddy Long Legs*. (Courtesy of the Mount de Chantal Visitation Academy Archives.)

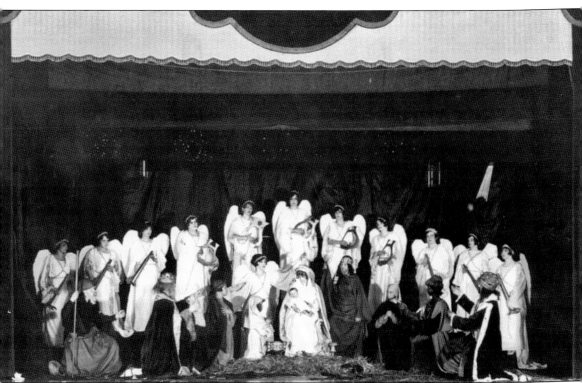

NATIVITY PLAY, C. 1926. In the Great Music Hall, student actors put on a performance of the Nativity. Kneeling in the front are, from left to right, Clara ?; Mary Crayle; Estella O'Brien; Kathaleen O'Brien; Helen Ford, Blessed Mother; Helen Floto, Saint Joseph; Mary Haymond, servant; Consuella Consiliari; and Cornelia, merchant. The angels are, from left to right, Ethel Check, Geraldine Lermmon, June Hill, Myrtle Phillips, Lexanne Wilson, Kathryn Lynch, Florence Dick, Dorothy Hickey, Margaret Hack, Katherine ?, Margaret Koessler, and Louise Kenna. (Courtesy of the Mount de Chantal Visitation Academy Archives.)

CROQUET, C. 1875. On a leisurely afternoon, the students and sisters of the Mount play a game of croquet. (Courtesy of the Mount de Chantal Visitation Academy Archives.)

900s. A student from the academy takes the shoreline to the Mount de Chantal trolley
12 s the residences of Wheeling were moving to outlying areas, trolleys became the
transportation from the suburbs of Elm Grove, Woodsdale, Elmwood, and Pleasant
. (Courtesy of the Mount de Chantal Visitation Academy Archives.)

MIDSUMMER NIGHT'S DREAM, C. 1891. Three girls from the Mount rehearse their lines i[n] outdoor setting. (Courtesy of the Mount de Chantal Visitation Academy Archive[s.])

DISCOVER THOUSANDS OF LOCAL HISTORY BOOKS FEATURING MILLIONS OF VINTAGE IMAGES

Arcadia Publishing, the leading local history publisher in the United States, is committed to making history accessible and meaningful through publishing books that celebrate and preserve the heritage of America's people and places.

Find more books like this at
www.arcadiapublishing.com

Search for your hometown history, your old stomping grounds, and even your favorite sports team.